T0193190

AWAKEN THE
CREATIVE
GENIUS
WITHIN

For greater success,
inner peace & happiness.
Why? Because it's time.

Lynne Evan Hoinash

BALBOA.
PRESS
A DIVISION OF HAY HOUSE

CHAPTER 8
Page 199

Setting the stage for success

By making your space work for you.
Set your intention.
Changing the energy in any space.

CHAPTER 9
Page 225

Bring your creativity to life & work

The importance of **being happy first**.
Gratitude does make a difference.
Being of service to others matters.

Page 248
Resources / Bibliography

Page 251
About the author

Note from the author

Throughout this book
I refer to the
morphic field of consciousness
that surrounds the planet as:
the Universe, God, Source Energy,
Love and Light,
Mother Earth and Father Sky,
and higher self, interchangeably.

Please feel free to use
the word or words with which
you resonate.

The words I used are the
ones that resonate with me.
I believe this book was
channeled through me, or at least
the good stuff was, from God or
Source Energy. Therefore,
these words work
for me.

Lynne Evan Hoinash

Welcome to my world

What you hold in your hands is a very unique and totally unusual book **written for business owners, entrepreneurs, and individuals alike.**

As the subtitle promises, this book is *"For greater success, inner peace, and happiness."* What is not stated, is that what you will learn from this book will help you enhance all aspects of your life.

It is based on my forty-plus years of personal study of consciousness, intuition, meditation, mindfulness, various healing modalities, art, and human behavior, which I studied from both a scientific and spiritual perspective. I did this concurrent with my work life in corporate America and later as an entrepreneur.

Yes I have credentials, I worked for Polaroid right out of graduate school as their International Advertising Manager for a 78-million-dollar division, for Digital Equipment Corporation, Trout and Ries Advertising, and Mort Barish Advertising before starting Red Wolf Design Group, an all-woman marketing/branding firm located in Princeton, NJ, which I founded in 1985.

What I have learned, and believe worth sharing is **how to be more creative, tap into your intuition more often**, appreciate the synchronicity in your life, have fun learning new skills that will amaze you, how to create an environment at work and at home that feels good, identify and eliminate any limiting beliefs that you have that may be keeping you from being fully present and alive in this very moment.

PS You will most likely have fun as you experiment with these tools.

Welcome to my world.
Lynne Evan Hoinash

But what's in it for you?

In this book I will present real life examples that can help you:
increase profits
improve employee engagement
give you a competitive advantage
How? By awakening the creativity and innovation of your people.

Here are a few typical challenges/stressors executives and individuals alike face almost on a weekly basis, and how using these tools and techniques can make a difference.

Indecision
Afraid to make a decision prematurely without all of the data, but if you wait you may not be able to meet critical deadlines?

Not sure which person to hire

How much to charge for a product or service

Where can you cut costs

What is missing from your presentation

You received a job offer out of state for much more money but

you're not sure if it is a wise decision

See chapters 6 & 7

Self Confidence
Not sure what people think of you, or what kind of first impression you make?

Have a critical presentation and you want it to go well

Concerned that you won't make the sale

Wonder if something is missing from your presentation

See chapters 5, 7 & 8

Stress

Do you feel like the pressures from work are getting the best of you?

Are you letting the little things bother you

Doubt you are doing a good job

Is your edginess affecting your employees' performance

Advice see chapters 4, 5 & 6

Leadership Issues

How to inspire other to be more creative, take risk by sharing new ideas that may not be in their direct area of responsibility, see the big picture, and be motivated by your vision of what is possible.

How to instantly defuse anger or hostility during a meeting

How to build teams that will work more effectively

Advice see chapters 2, 3, 4, 5 & 6

Other issues?

How to gain a competitive advantage—read the book

How to enhance creativity—chapters 2, 3, 4, & 7

How to engage others to get behind your project—chapters 1, 2, & 9

For inner peace and happiness—chapter 3, 4, 5 & 6

To feel in control during a meeting—chapter 7 & 8

For answers to specific questions, close your eyes and
open the book anywhere and begin reading.

Notes to yourself

Why creativity matters

Why the sudden focus on creativity?

For Management profitability | viability | survival | success
Today, business people across all industries are recognizing the importance of **creativity, innovation, and design**. Business experts believe that these talents are critical in order to compete, and that only those companies that value these attributes will survive, thrive, and be profitable.

All we have to do is to look at companies such as Apple, Google, and Amazon to know that this is true.

But how do companies find creative people who will ensure their survival and profitability?

It is simple. **These people already work for you.**

Simply change your belief that creativity is a gift bestowed on only a small percentage of people in the world to the realization that all people are naturally creative. The challenge is to create an environment where creativity is valued and to help people awaken their creative genius within.

This book is designed to help your people: realize that they are all creative, discover their unique talents, learn ancient tools and techniques, embrace a spirit of playfulness, and use art—including doodling—to access the right side of their brain. This unique approach helps people rediscover just how much fun it is to be creative and how to bring this attitude into all aspects of their business life.

For Employees job security | upward mobility | overall happiness
Want to ensure job security? Then it's time to *Awaken the Creative Genius Within*. Not only is it fun and easy, you will have more joy and laughter in all aspects of your life.

Introduction

There is only one scary thing
about enhancing your creativity.
It may be fun.

This book is written for both left-brain and right-brain readers.
If you generally read nonfiction books in a linear fashion, from beginning
to end, you may notice a few paragraphs repeated verbatim. This was done
intentionally—first, to reinforce the importance of these concepts and
second, for the benefit of those readers who skip around, reading only those
chapters that appeal to them—you know, you right-brain people!

For those of you who are serious business people, you may notice the
overuse of words such as: playing, laughing, smiling, and having fun. That
too, was done on purpose to reinforce that "awakening your creative genius
within" doesn't have to be serious . . . or feel like WORK!

The first and only rule we have for you is . . . there are no rules! If you
had to follow rules in order to play, then play would be work.

**This book reveals the secret to mastering the skills you need
to succeed in business and, maybe even more importantly,** to
consistently **have more fun** in all aspects of your life—including attending
staff or board meetings, playing with your children, grandchildren, and
family pets, and talking to strangers.

You will learn how easy it is to:

- **Develop your creativity**
- **Harness the power of your intuition**
- **Tap into the wisdom of your heart**

Our promise

We promise that learning this unique approach to awakening your creativity and intuition **will be fun and easy to master!**

You will be a different person for
having bought this book,
whether you read one sentence,
one paragraph, one page,
one chapter, or never read it at all.

You will see business issues in a totally new light.

It will give you permission to play for the sake of enhancing your creativity and your ability to become more innovative.

You will smile more and appreciate the value of play.

It will expose you to an entirely new set of tools and techniques, many of which you may never have heard of, but may find intriguing and worth trying—such as hand mudras, working with a pendulum, mindfulness, and using tuning forks to help drop into various states of consciousness conducive to meditation, and enhanced creativity.

You may be surprised just how natural it feels to use these tools and techniques—almost as if you remember using them in past lives.

You will be more intuitive, and trust your intuition.

You will awaken to the fact that you are creative, with innate abilities you never knew you had or never took the time to appreciate.

You will learn how natural it is to access and harness your creativity.

What is creativity?

"Creativity takes courage."

Henri Matisse

Creativity is a mindset.

It is pure energy. It is who we all are.

It is an inner realization that we get to create our reality, based on our beliefs, the stories we tell ourselves, and our intentions.

It is freedom—freedom to make it up.

It is the willingness to be who we truly are and to take risks without worrying about what other people will think.

It is the realization that there is no such thing as failure. Rather, what we may label as a failure may just be a slight detour in order to learn something that we will find invaluable years from now.

Being connected to our creativity is what makes being alive fun.

We are the most creative when we are aligned with our higher self, which is aligned with and open to the love and light of the Universe, God, Mother Earth, *or whatever name you may be comfortable using.*

How do people experience creativity? As an idea that:
- Appears out of nowhere
- Is perfect the moment it occurs
- Surprises you
- You know that you didn't generate

Get ready to have fun

"Every child is an artist.
The problem is how to remain an
artist once we grow up."

Pablo Picasso

It seems that, all of a sudden, some of the most prestigious business magazines, including *Harvard Business Review, Wired, The Economist, Fast Company, Fortune,* and *Business Week* are featuring articles advising companies that in order to be successful and survive in the coming years, they will have to appreciate the importance of:

- Creativity
- Innovation
- Design

While there are countless books on each of these subjects, most are written from a purely academic perspective. Boring!

My approach is different. This book introduces you to a variety of tools and techniques, and provides the information you need to experiment with them firsthand. These tools and techniques will help stretch your imagination and awaken the creative genius within.

My hope is that this book **will help you appreciate the power of play**, without guilt or feeling that play is a total waste of time and energy. In fact, you will learn that playing serves as a direct link to enhancing creativity and innovation—not only in business, but also in every aspect of your life. Pretty exciting!

So move over children,
we have come to
take back our toys!

How to use this book

Think of this book as your personal magic genie in disguise. Reading it will help you let go of limiting beliefs, access your inner knowing, and much more—as long as you keep an open attitude.

If you want to scan this book, I have made that easy for you. Just read the words set in bold. And, please don't try to make sense of the words I decided to bold, or look for a consistent pattern—there is none.

Want to try out one technique right now? Good. You can. All you have to do is think about any situation, challenge, or question where you would like additional insight or answers.

Be specific and really address the heart of the issue. Decide it will work, which is called "setting an intention" for your desired outcome. For example, you can say,

<div align="center">

I access the insight and answers
I need easily, quickly,
and magically!

</div>

Step 1 Think of your question and move your focus of attention from your analytical brain to your loving heart.

Step 2 Find a book, now feel the essence of your question, open the book to any page.

Step 3 Start reading where your eyes stop. You may want to read a sentence, a paragraph, or the entire page. Reflect on the information you intuitively chose. Did it provide any guidance? If not, choose another page and see if that contains information that seems helpful.

Step 4 Keep an open mind. Don't prejudge the value of the answer. Rather, sit with the insight you received to see if it resonates as true. Give thanks either way and go back to your reading . . . or not. The insight may become apparent later on. Now if you think this is a less-than-effective means for gaining a new perspective on an issue, then you are right. But try this experiment again with one simple difference—See Step 5. .

Step 5 Decide you will get an answer that is spot on. How does that feel? Now take three deep, slow, calming breaths and smile. Drop your attention down to your heart and say:

I request an answer from the heart,
that is truthful, and honest.
May the insights I receive help
me, and help me serve others.

Step 6 Open the book again to any page and see what happens. Repeat this approach as often as you like and with any book. Stop when you become bored, or when you get the insight you need.

Step 7 Experiment by asking the question in different ways to see what insights you get. For example, instead of asking, "Will my presentation to the board come across as clear and decisive?" Be more specific and ask, "What do I need to address in my presentation to strengthen the delivery of my message, create credibility, inspire the board and gain their support?"

Know that important insights and answers may appear anywhere. Remember to be open to receiving guidance from all types of sources— newspapers, magazines, ads, or an image on a billboard. Have a playful attitude and make a game out of finding guidance in strange places.

Who knows? You may find some meaningful insight on the side of a cereal box. **Never prejudge the wisdom of the Quaker Oats man.**

Want to record your questions and answers. That's simple, just text yourself the question and take a picture of the answer, page number, and the cover of the book.

If you think this technique seems silly, that is fine—you don't have to believe it will work in order for it to work. Studies shows that being playful, curious, and letting yourself try new things enhances creativity.

How so? You may be surprised to learn that scientific findings of leading neuroscientists, along with insights gleaned by a play behavioral expert and author **Stuart Brown, MD, validate the importance of play.**

Dr. Brown's book, *Play: How it Shapes the Brain, Opens the Imagination and Invigorates the Soul* and his TED Talk are worth exploring.

Dr. Brown has conducted more than 6,000 play histories on people from all walks of life, including CEOs, Nobel Prize winners, and even serial killers. Drawing not only from his years of clinical research, but also from the latest advances in neuroscience, biology, psychology, and social sciences, Dr. Brown's work provides cutting-edge insights backed by statistics that will change your perception of the value of play.

Other reasons to buy this book:
- It will help you stay relevant at work and may help you get ahead
- So your boss will see it on your desk and be impressed
- A friend or colleague recommended it
- You know you are creative, but you'd like written validation

Need a more left-brain approach? Then look at the table of contents and turn to any chapter that grabs your attention. Never feel obliged to read an entire sentence, paragraph, page, chapter, or even the entire book. You can skip around and read pages in any order. Just know that whatever you read or learn will be perfect for you at that moment in time. Don't be surprised if you find yourself coming back to this book anytime you have a question or need to make a decision.

This book will give you a certain sense of legitimacy when you use one, or any combination of the tools and techniques I have assembled to help you enhance your creativity. After all, if information appears in a book, it must be valid. Ha ha!

Even if you never read this book, but rather keep it on your desk just as a prop, it will be well worth the price just to see how various employees, clients, prospects, and vendors either react or don't react to its mere presence. You may be extremely surprised at how the vibrational energy of this book affects people, and at the conversations and connections you may make on a deeper, more authentic level just because it is there.

Want to be really devious in a fun way and get someone's attention? Have multiple copies of this book casually spread out on your desk, just enough to reveal a Post-It Note on each one with the CEO's or CFO's name (unless that's you!) with a message saying, "You have to read this." If this doesn't get a person's attention, and if they don't notice or ask about this book that automatically speaks volumes about the person.

This is also a great book to give to your friends, employees, and even colleagues at different companies, just to see how each one reacts and who will actually read it. When you give the person a copy, ask her to promise to read at least one sentence, one paragraph, one page, one chapter, or any part of the book and to pass it on to someone else when they are finished with it.

After you read this book, you may be inspired to get together with other coworkers who have read it and start experimenting with the techniques you will learn such as: how to use a pendulum, a few mudras, doodle before going to a meeting, or decide to be mindful for the afternoon. Don't know anything about pendulums or mudra positions? That's fine, it's covered in chapter 7.

Want to really get people talking? Use a pendulum to double check your answer to a question, hold a hand mudra under the table during a meeting, or take doodle for ten seconds just before a meeting.

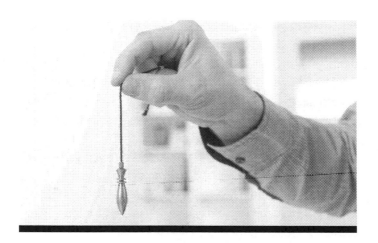

Here is what a pendulum looks like. Want to experiment with a pendulum? It's easy, you can buy a pendulum, along with a copy of my book *Awaken the Creative Genius Within* **Using a Pendulum** at the store on my website: redwolfdesign.com. The book gives you charts for all types of decision making, along with charts that you can copy and customize for specific situations. Remember, the idea is to first decide on a course of action, and then see what the pendulum tells you. Go to chapter 7 if you want to learn how to play with a pendulum now. Until you buy a pendulum, you can make one using ordinary objects that you probably have in your home or office.

Here is an example of how I use the pendulum. I decide that my marketing budget for next year is $150,000. I want to check if this amount is correct. I also want to check if what I have allocated for each line item is on target. So I write down $150,000 on a piece of paper, hold the pendulum over the number, think about what it is that I want to accomplish,and then ask "Is this the right investment level for what I want to accomplish?"

If it indicates yes, I may continue asking more specific questions using a chart from my book to determine if I am allocating the right amount of

money for each line item. If it tells me no, I can write down the name of each line item—such as radio advertising, billboards, social media—and check each one to see if I should spend more or less. If it confirms that I should spend more, I can use a percentage chart in the book, to help determine how much more—such as 10% more in radio advertising. Often, even after I change the investment percentages of several items, I still come out with the same total, which I think is very cool.

Here is an example of a mudra position. This hand position is often used for meditation or contemplation. To learn about mudras, I recommend using the mudra card deck entitled *Mudras of Yoga* by Cain Carroll with Revital Carroll. You will find more detailed information in chapter 7.

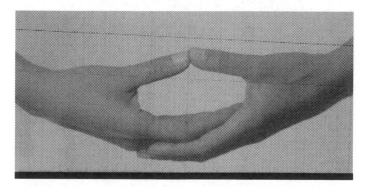

"When you change
the way you
look at things,
the things you look
at change."

Max Plank

Nobel Prize Winner

Attitude and perspective

Creativity is magic.

You are creative whether you know it or not. This book will help you discover and reconnect with who you truly are: a fun, playful, exciting, and creative being who is able to create what is next—whatever that means to you. The exciting part is that once you declare that you are creative, your attitude and your whole demeanor will shift and you will become more creative in every aspect of your life. Try the following:

On a scale of 1 to 100, how creative do you think you are? _____
What number would you like that number to be after reading this book and using some of its tools and techniques? _____.

Now pretend that you just took a highly scientific creativity test and you are sitting with your boss to find out how you did. You realize that the score must not be good based on his body language and the uncomfortable look on his face. Now hear him say that your score was 31 out of 100. Really feel the effect of that imaginary scenario. Consider your posture and body language. Do you feel like the man below? Isn't it amazing how powerful our thoughts

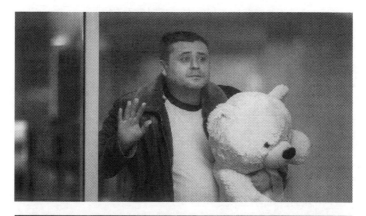

are. Now shake off that feeling because it doesn't serve you. Here is what you can do next.

Imagine the very same scenario, only this time, visualize your boss' body language and his facial expression when he tells you that you scored in the top 1% of everyone who took this creativity test worldwide!

See how powerful even a fake test and score can make you feel. If just imagining getting a low score can be totally dis-empowering, then getting a high score will be intoxicating right?

So just by pretending that you are highly creative, the thought becomes a self-fulfilling prophesy.

It changes your energy, your posture, and your attitude. Try it and see how quickly everything changes, including your mood.

Now decide that neither number matters. Instead, tell yourself that your level of creativity is off the charts and more than **333 or any other number you like.** You can use this number as a trigger to reinforce this belief simply by thinking and repeating this number to yourself throughout the day. Do this for several days and see how this exercise makes you feel. Chances are you will stand taller, feel much more creative, and give yourself permission to smile. **After all, your creativity is off the charts.**

Here are a few things to remember:

- Decide that you **are naturally extremely creative**
- Give yourself **permission to play and have fun**
- **Be willing to learn new things**—just because
- **Promise to let go of your limiting beliefs**

For more information on getting rid of limiting beliefs see chapter 3.

Why don't we feel more creative? It may be based on our belief which comes from the fear of being labeled a "creative type." Why is that term considered bad? In the past, that label meant that the person was:

- Not in touch with reality
- Devoid of business sense
- Flaky and not to be taken seriously

But life evolves. Today, businesses realize just how important "creative types" are to their survival, viability, and profitability. At last, being considered creative is a very good thing!

Business pundits across all industries proclaim that the most successful companies are those that value and promote creative ideas, produce innovative products, and appreciate the importance of elegantly designed products and packaging. Just look at Apple.

Not only does Apple create products before we have any idea we need them, but their product designs and packaging are so artfully done that when we purchase an Apple product—even if it is only a charger—we feel we are part of an elite, tech-savvy culture and are mysteriously compelled to save the box.

Fast forward and observe just how many companies that manufacture everything, from golf balls to automobile parts, are redesigning the look and feel of not only their product, **but of their packaging as well.**

So now that the rules have changed and being "creative" is perceived as a highly desirable, the question is, how do you reinvent yourself to be perceived as "creative" by everyone, especially by senior management? And is that really an achievable goal? I believe it is.

Is having fun and playing critical to enhancing your creativity? Yes! But it was only after I read Dr. Stuart Brown's seminal book, *Play: How it Shapes the Brain, Opens the Imagination and Invigorates the Soul* (2010) and watched his TED Talk, that I really appreciated the body of work he has produced on the science of play. Happily, it validates what I teach when consulting, conducting seminars and workshops, and in presentations. Dr. Brown also explains why play is essential to our problem solving ability.

Ready to practice just a little? Here are a few exercises you can do. If you only have time for one, try the first—you may find it invaluable.

1 First, with your eyes closed, declare to yourself that you are very creative. Explore how that feels. Does your posture change? Are you feeling more self-confident? Are you smiling?

Realize just how powerful your belief system is. Write in your name below and read it out loud several times. Make this your new mantra. Copy this one line on several Post-It Notes and place them all around your house, and even in your desk drawers. See how quickly your self image shifts.

I_____ am the most creative person I know!

Next, take a few deep breaths. Close your eyes again and picture yourself doing something creative. It can be something as simple as discovering that you can wind up your cell phone's cable and keep it in place by twisting a pipe cleaner around the cable, or seeing yourself holding several highly-sought-after patents in your name.

Now see yourself ringing the bell at the opening of the New York Stock Exchange because the company you started went public in three years and you are now worth a half a billion dollars thanks to a successful IPO, or see yourself winning the Nobel Peace Prize.

Notice in your mind's eye that you are smiling. See a field of positive white energy surrounding you and enjoy how it feels to be in the moment.

Did you know that your subconscious mind says "yes" to everything you declare to be true? So start declaring that your thoughts and actions are creative, being sure to use the present tense.

For example, the next time you take out the garbage or empty the dishwasher imagine that the way you are performing this mundane task is highly creative. Don't think about it. Can you see yourself doing this task differently? Your actions may look exactly the same, or you may find new ways of doing routine tasks that make the activity easier.

2 Imagine you have a solid cube made of wood that measures 18" x 18" x 18". Now take out a piece of paper and quickly make a list of everything you could do with one of these cube.

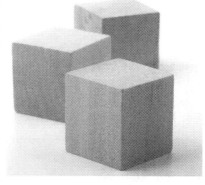

Only give yourself a minute to do this exercise. Be as outrageous as you like. As the day goes on, add to this list as ideas pop into your head. How did it feel when other ideas came to you while your "mind" was on something else? You can also ask others for their ideas. This is how creativity works. Remember creativity doesn't have to be solitary.

Notice that once you give your mind a challenge, it will keep searching for a solution while you are showering, driving, watching TV, or about to fall asleep. Right?

Back to the cube of wood. Want three hints? You can give the wood away, you can give the assignment to someone else, or you can burn the wood. Did that help?

3 Next exercise. Look around the room you are in, or imagine a room you know well. Now pretend that it has very large windows. How would that look, and how would that change make you feel? Imagine that every wall was painted a different color? Visualize adding new items to the room—what would you add? How does that look? Remember, this is your room. You can add artwork, sculptures, furniture, rugs, tables, lights, or anything else that pops into your mind—including exotic animals and pets.

Back to your room, now you can also eliminate specific items. What do you see? One option is to empty the room of everything and start with a clean slate. Now what do you see? Do it all over again, what do you see? The point of these exercises are that you get to make it up, and they are great for enhancing your creativity.

Were you surprised by what you could instantly envision? Did you notice that ideas and pictures popped into your head when you may have expected to come up blank? Were you surprised and delighted by just how ideas and elements appeared and disappeared from the room? **Good job. See how fun and easy it is to be creative?** Case closed.

Once you decide that you are highly creative, you will see life in a totally different light. You may begin to envision what you really could create without any limitations. When shopping at Home Depot or Lowes you may imagine many other uses for the hardware parts and pieces they sell—especially in the plumbing and lumber aisles.

Deciding that you are creative also gives you permission to do silly things. Imagine what would happen if you wore two obviously identical, but different-colored shoes when you went out? I did just that one sunny summer Saturday in Princeton, NJ. Why? Just because I thought it would be fun, like having an additional pair of shoes. I got dressed and ready to leave the house, but was delayed by two miscellaneous phone calls, deciding to first throw a load of laundry in, and feed the cats. By that time, I had totally forgotten that my shoes didn't match.

Guess what? Total strangers of all ages, both men and women, came up to me with disturbed looks on their faces—and out of grave concern proceeded to tell me that my shoes didn't match. It was as if they were warning me that they kill people when their sandals don't match! Most of these concerned citizens were startled when I told them I had done it on purpose. Their reactions were more dramatic than I would have ever expected, perhaps because I was otherwise well dressed. I wonder if anyone would have been concerned if I was a homeless woman.

Sometimes being totally outrageous is fun and lets you explore your creativity and self-expression. **It is even more fun to create an fun opportunity for someone else** to be totally spontaneous. For example: I am playing girly jewelry time with my great niece, Kendall Leigh Moll just because. Playing with a child is so joyful and brings you into the ever present Now.

"*Play energizes us and enlivens us. It renews our natural sense of optimism....*"

Stuart Brown, MD

The importance of play . . . really?
Why play matters —just ask the expert.

In Dr. Stuart Brown's book, *Play—How it Shapes the Brain, Opens the Imagination and Invigorates the Soul,* he states, **"The advantage that countries** like the United States, Britain, France, Germany, the Scandinavian nations, and Japan retain is the ability to invent—**to dream up solutions to problems** that people may not yet even know they have."

"Nations that remain economically strong are those that can create intellectual property—and **the ability to innovate largely comes out of an ability to play."**

You may want to know that one of my underlying premises is validated by the findings of Dr. Brown, a leading expert on play behavior. He has completed over 6,000 play histories using people from all walks of life— including CEOs, Nobel Prize winners, blue-collar workers, professors, teachers, and even serial killers.

Drawing not only upon his years of clinical research, but also upon the **latest advances in neuroscience,** psychology, biology, and social sciences, Dr. Brown's work provides cutting-edge insights backed by statistics that will change your perception of the value of play. Note to reader: I told you I would repeat things that I believe worth repeating, because some concepts may be difficult to grasp at first.

According to Dr. Brown, play actually has the power to shape the brain. Here are a few excerpts from Dr. Brown's most enlightening book:

"Play lies at the core of creativity
and innovation."

"Play is anything but trivial.
When we play, we are open to
possibility and the sparks of new
insights and thought. Play
fuels our creativity."
Stuart Brown, MD

"Play energizes us and enlivens us.
It renews our natural sense
of optimism."
Stuart Brown, MD

"Once people understand what
play does for them, they can learn
to bring a sense of excitement
and adventure back to their lives,
make work an extension of their play
lives and engage fully with the world."
Stuart Brown, MD

> "We are designed to find
> fulfillment and creative
> growth through play."
>
> Stuart Brown, MD

Okay, so now that the left brain is adequately appeased, it should grant you permission to have fun—if only under the guise of enhancing your creativity in order to be more innovative and successful at work.

While the left brain is still pondering the quotes above, quickly read on, allowing **your right brain to take over and begin to play before the left brain tries to sabotage you.**

P.S. Dr. Brown gave a great Ted Talk on the importance of play, which is well worth watching. It is entitled: Play is more than just fun.

"Whether
you think you can,
or think you can't,
you're right."

Henry Ford

Let go of limiting beliefs

You just have to give yourself permission.
It's really that easy when you know how.

Not quite sure what a limiting belief really is? Think of a limiting belief as a software program running beneath the surface of our **awareness that controls and limits our access to what is possible.** It is similar to wanting to write a business letter on your computer when the only software program you have is a drawing program—you get the idea.

Why aren't we always aware of our limiting beliefs? Probably because our limiting beliefs, which run 24/7, were **formed before we were seven years old,** and are hidden in the recesses of our subconscious mind.

Even people familiar with the term "limiting beliefs" can have difficulty identifying their own underlying limiting beliefs. The fact that most people have many limiting beliefs further complicates matters.

So where do these limiting beliefs come from? Other people. Parents, relatives, teachers, friends, and even strangers may have said something about us or about the world that we heard and believed was true. Just imagine the impact on a child hearing someone say in frustration, "She must be stupid," or "He'll never amount to anything."

What makes matters worse is that our subconscious mind wants to make us happy. It does this by agreeing to everything we believe and say is true. For example, you can say or think, "I'll never lose weight." As soon as you tell yourself that this is true, your subconscious mind works behind the scene to make this true—no matter what it takes.

So be conscious of what you tell yourself. A better thought to tell yourself is "My body is thin, lean, toned, flexible, radiates health, joy and vitality." Try repeating this statement right now. Did you notice that just by repeating this affirmation you instantly sat up straighter? Try it again and it will still have a beneficial effect.

Because the subconscious mind believes everything that it hears, just imagine what happens when a child or an adult hears someone remark: "She'll never be an artist," "He can't sing to save his life," "Why does he want to try out for the team when he is so uncoordinated?" Or hears a parent comment, "Her teacher is really concerned about her ability to learn math." It is only natural for the child to decide that these statements are true, whether they are or not. These beliefs often become self-fulfilling prophecies.

Did you know that limiting beliefs may be passed down from one generation to the next without anyone ever verbalizing their beliefs out loud? Instead, the vibration of these beliefs is programmed into our DNA at the level of our subconscious mind and is passed down at the cellular memory level from generation to generation.

Limiting beliefs generally center around outward appearances, self-worth issues, lack of a specific talent or ability, or lack of money and resources. Here are some of the most common limiting beliefs:

- I'm not enough
- I'm not good enough
- I'm not smart enough
- No one will ever love me
- If I love another person, they will leave me (abandonment issues)
- I can't trust anyone
- People are only concerned about themselves
- Life is hard and you never get anything for nothing
- I am not lucky
- Bad things always happen to me
- I'll always be broke or poor

Want help identifying your limiting beliefs? That's easy. Look at your life. Now ask yourself these innocuous questions: On a scale of 1 to 10, how happy are you with your:

	Today's score	After reading this book & using the tools
• Life in general	_____	_____
• Relationships	_____	_____
• Health	_____	_____
• Finances	_____	_____
• Career	_____	_____
• Where you live	_____	_____
• Car	_____	_____
• Friends	_____	_____

You can make the list as long as you like. Just choose one area where you are the most dissatisfied, or where you want something you don't currently have. **For example, pretend that you'd love to have a new car** and

that you really don't want just any new car, but one that you think is totally out of the range of possibility. Close your eyes, be honest. What car or other "missing thing" comes to mind?

Chances are, if you are always telling people, or just yourself, how much you'd love to have a new black 4-door BMW convertible or a _____ (*fill in the blanks—year, make, model, and color*) but that shiny new car still isn't in your driveway. Congratulations! You have just discovered an area in your life where a "limiting belief" may be hiding.

Here is a dialogue that may be running in a continuous loop in your mind. "I really want a _____**."** (*fill in the blanks*) "I really want it." "It's not fair that I don't have a new car." "John just bought a new car, so why haven't I bought myself a new car, especially since I know I make more money than he does?"

While your conscious mind is running one tape, your subconscious mind might be telling you a totally different story based on your limiting beliefs. These limiting beliefs may be centered around issues of money, self-worth, self-love, fear of not having enough, belief that you don't deserve nice things, what would your parents or friends think, etc.

If you think money is the only thing that is preventing you from having a new car, you may be wrong. It just may be that your subconscious mind is telling you, "Well, even though you can afford a new car, just think about all of the other expenses— gas, insurance, repairs, parking, car washes, and detailing." Chances are your limiting beliefs around having a new car are stronger than your desire to own a new car.

Money may not be the only issue at hand. As a child, you may have heard things from your parents such as: "You can't trust car salesmen," or "It's a waste of money buying a new car."

Want to identify your limiting beliefs? You know, the ones that have been there forever and are currently alive and well in your subconscious mind? You can ask your higher self for some insights, play my game below, or consult with a psychologist, psychiatrist, or hypnotherapist.

Want to know my favorite way to determine my limiting beliefs? I use a pendulum. While you will learn how to work with a pendulum in chapter 7, here is a chart you can use.

First question you want to ask is, "Can the pendulum help me discover what my limiting beliefs are?" If yes, proceed. If you get no for an answer, rephrase your question and ask, "May I ask this question at a later time?" Generally, you can proceed a few minutes later, or when you are not feeling rushed. Now create your own chart, which may look something like this:

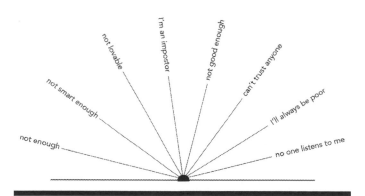

You can also design your own chart to determine what are the underlying beliefs that may be sabotaging your ability to succeed. There are two ways to discover what is holding you back. You can write down and test each statement for a yes or no response. Or you can put the point of the pendulum over the dark half circle in the center and say to your pendulum, "Please show me my strongest limiting belief." Once you get a response ask,

51

"Do I have another limiting belief I should be aware of?" Continue until the pendulum stops moving when you ask this last question again. Write down your answers in the order they appeared. Here are a few more limiting beliefs to consider:

- I need to be in control
- I need all of the information before I can proceed
- No one does anything right—all of my employees are idiots
- I want everyone to like me
- It is quicker to do things by myself

How to let go of limiting beliefs

These limiting beliefs may be thoughts such as: I am not creative, only kids have the time to play, or I am not good enough.

How do you free yourself of your limiting beliefs? The first step is for you to realize that we all have limiting beliefs, whether we know it or not. Cognitive Behavioral Psychology recommends the following:

- Identify your limiting beliefs
- Choose a positive belief to eliminate the original belief
- Think about the cost of holding onto the limiting belief
- Ask yourself what it has already cost you to keep these beliefs

Make a commitment to eliminate your limiting beliefs. Take a minute to visualize yourself writing these beliefs down on piece of paper or on a white board. Now see yourself either crossing them out or erasing the words. Now visualize writing new, positive, affirming beliefs. Some people find it helpful to write their affirmations on Post-It Notes and have them all around their house.

Many people decide before the age of seven that they are not creative, based on their definition of what creativity looks like. More than likely, this is a belief based on their inability to: draw naturally, play an instrument by ear, or sing fabulously well—all without any training.

But who is to judge what talent looks like? Chances are if you saw some of the early works of artists such as Vincent Van Gogh, Pablo Picasso, El Greco, Johannes Vermeer, or Paul Gauguin without knowing who painted them, you might not be impressed. You might in fact think their works were mediocre at best.

Did you know that Vincent Van Gogh was self-taught? That his brother, Theo, supported him throughout his lifetime? That he was also plagued by a deep sense of guilt that he was wasting his brother's money whenever he bought paint, brushes, and canvases?

Flash forward. Did you know that Van Gogh's painting *Portrait of the Artiste Sans Barbe* recently sold for $17.5 million, while only one of his paintings sold in his lifetime? And that painting was bought by his brother, who was an art dealer? At the time of Van Gogh's death at the age of thirty-seven, Vincent had already completed over 900 paintings. A staggering number, especially as he didn't begin painting until he was twenty-eight years old.

In fact, many of the "now famous" impressionist painters such as Paul Cezanne, Edgar Degas, Edouard Manet, Camille Pissaro, and Pierre-Auguste Renoir were considered radical in their time and ridiculed by the public because their works did not adhere to what was deemed proper by the *Academie des Beaux-Arts.*

In the late 19th century, the *Academie* dominated the French art world and was viewed as the preserver and enforcer of traditional French painting standards of both content and style. At the time, artists were expected to restrict their paintings to historical subjects, mythological scenes, religious themes, and portraits. Landscapes and still lifes were not considered appropriate subjects, and painting outdoors rather than in a studio was highly frowned upon.

Thankfully these impressionistic artists carried on and did not succumb to the opinions of others.

While some children don't think that their artwork isn't any good, did you know that many of the most famous artists accumulated a collection of children's artwork for inspiration? It is true. Just read the book *The Innocent Eye* by Jonathan, Fineberg. He shows that there was a direct and explicit connection between the artwork of modern masters such as Klee, Kandinsky, Picasso, Matisse, Jackson Pollock, and Miro and their collection of child art work these artists owned. In fact, Sir Herbert Read said that in 1945 Pablo Picasso said the following while viewing an exhibition of children's drawings:

> "When I was the age of
> these children
> I could draw like Raphael.
> It took me many years
> to learn how to draw
> like these children."
>
> Pablo Picasso

Just remember the words on this sign. Decide what is stopping you, let those beliefs go and get on with your life.

When you aren't living life
to your full potential,
you are cheating the world
out of the unique talents
and gifts you received
from the Universe.

"Today art continues to be
an effective and powerful means
for self-discovery . . . and it can
help you be in the moment,
enrich your life and help
you access your own
innate creativity."

Betty Edwards

Art holds the key

Turn off the left side of your brain and let the
right side come out and play.

Here are a few things to keep in mind
as you read this chapter:

Keep it simple.

Learn how to appreciate and
access your right brain.

Want to reconnect with your creativity?

Examine what you really believe.

**Just like any other skill,
drawing can be learned.**

Discover your creativity
while doing the mundane.

"Goodbye," said the fox.
"And now here is my secret,
a very simple secret:
It is only with the heart that one
can see rightly; what is essential
is invisible to the eye."

Antoine De Saint-Exupéry
From *The Little Prince*

My approach when looking at the big picture

I believe that painting is:
27% painting, **64.45%** shopping
22% reading books about how to paint
43.55% getting ready to paint,
1% inspiration and
100% enjoyable.

Lynne Evan Hoinash

Oh, did you know that when you come from the right side of your brain and from your heart, **numbers don't always have to add up to 100%—** because where is the fun and creativity in that? I'll bet when you initially saw the numbers, your left brain was happy, until it became obvious that the total exceeded 100%. How very silly of me! **100% enjoyable!**

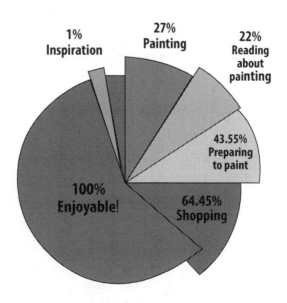

Overview

The fine arts have been used for self-expression, communication, recreation, ceremonies, and ritual throughout history. Today, learning how to draw continues to be an effective and powerful means for self-discovery. In fact, learning to draw can help you be in the moment, make you happier, and enrich your life. **But did you know that learning how to draw is also one of the keys for unlocking your own innate creativity?**

How does learning to draw enhance creativity?

It does so in many ways. But first, to clarify, when we talk about "learning to draw," we aren't implying that you should spend years taking art classes to master every aspect of drawing and painting. Rather, I recommend that you use Betty Edwards' method, which is easy, fun, and very effective.

Betty Edwards is the author of *Drawing on the Right Side of the Brain, A Course in Enhancing Creativity and Artistic Confidence.* Over a million copies of the book have been sold. Her accompanying workbook with the same title is designed to prove that anyone can learn to draw by simply doing the exercises in the workbook at their own pace.

Betty Edwards believes that learning to draw is a means to an end, where the end is enhancing your creativity, not producing artwork.

Edwards determined that there are five skills within the realm of learning to draw. While these five skills are not considered a part of the "traditional" drawing skill set, they are key for using the act of drawing to enhance creativity.

The five fundamental are: how to perceive edges, spaces, relationships, light, and shadow are also key skills necessary for seeing. While Edwards' method of teaching was considered revolutionary when she first published her book in 1979, it was immediately embraced and is now widely accepted. Ms. Edwards determined drawing helps you:

- Switch to the right side of the brain—*the creative, visual, non-verbal, intuitive side*—and see things differently
- Tap into higher states of consciousness, bypassing your left brain— *which is verbal, linear, and analytical and wants to be in charge*
- Learn how to be in the moment and go with the flow
- Get comfortable taking risks
- Reconnect with the joy of being playful and having fun

All important skills in business.

Ready to learn Betty Edwards' method? While Edwards' book and workbook stand on their own, reading the book helps you appreciate the power of what you will learn. I recommend reading or skimming her book, working through her workbook, and watching her DVD, *Drawing on the Right Side of the Brain* (*which guides you through the lessons presented in the workbook*). You can purchase all of the supplies you will need for the exercises in the workbook on her website.

If you order the portfolio, you don't need to order the DVD, as it is included in the portfolio. While many of the items in the portfolio are readily available, a few of them are difficult to find, so if you are interested it may be easier to order the portfolio and workbook all at once. Everything can be ordered at drawright.com, where you will also have access to sample exercises.

Before your left brain tells you that "you will never be good at art so why even try," spend two minutes and Google Betty Edwards. Then scroll down and click on Images for Betty Edwards. You will see a host of before

and after self-portraits done by her students. If this dramatic demonstration of how much a person can learn after just a few hours of simple exercises doesn't convince you, reading her book or watching her DVD will.

Keep it simple. Doing any form of artwork is a great way to enhance creativity. As we have mentioned, the act of drawing switches your mental processes from your left brain—*which is language-based, analytical, and linear-thinking*—to your right brain—*which is non-verbal, intuitive, and visual.* Even the simplest act of "doodling" works.

In fact, some art classes begin with students drawing big loops and then smaller loops as a warm-up exercise to get the right brain activated and engaged. It also loosens your hand, mind, and attitude.

Try doodling for a minute or less before going into a brainstorming meeting. Use it you are struggling with a business issue and want to tap into your intuition.

It can make a difference and help you see challenges in a whole new light. Any type of drawing that you do can make you smile and transport you to a different world of endless possibilities.

One of the real benefits of learning to draw is that it trains you to look at things differently and to see them in new ways. These same new perceptual skills can be applied in both thinking and problem solving.

Henning Nelms states in his book, *Thinking with a Pencil,* " **In the history of inventions, many creative ideas began with small sketches."** To prove his point, he goes on to show a few small sketches done by Galileo, Jefferson, Faraday, and Edison. Some of the most revolutionary ideas started with a quick drawing no larger than two inches by three inches.

In another one of Nelms' books, entitled *Rapid Viz, Third Edition,* he teaches a simple approach to drawing that helps people capture their ideas, deferring their judgment until later. Another easy and enjoyable book is *Draw to Win* by Dan Roam.

Why it is essential to learn how to appreciate and access your right brain? Today, businesses often expect employees to constantly increase productivity, to get work done and then move on to the next task, assignment, or project. This leaves little time, and even less energy, for creative thinking. When employees are asked to be more creative, it can sound like just another thing to add to their already exploding to-do list.

It is as though we have forgotten that we all are innately creative, that there are easy ways to access the creative side of our brains, and that doing so is actually fun—as long as we don't take ourselves too seriously.

Why do so many people think they aren't creative? It may be because kids often stop drawing before ten years of age. Schools that eliminate art and music classes are doing students and society a grave injustice, which will become apparent as students enter the workforce and their employers realize that fewer and fewer young people seem like creative thinkers.

Adults may never try drawing because of their fear of failure. Taking risks is an integral part of exploring painting or drawing. So in a way, you can think of creating art as the means for practicing taking risks and risking failure—two skills needed to succeed in business.

Want to reconnect with your creativity?

It's easy. Just decide to do it. The good news is that you get to make up your approach. You get to intuitively play with whatever items appeal to you. If you have children, you probably have a lot of great art supplies to play with like colored paper, markers, etc. If you don't have kids, you can buy a few supplies or improvise. You'll also want to have some copy paper, an old magazine, newspaper, junk mail or a catalogue, a pair of scissors, and tape or glue at the ready. It is also great to have a few large pieces of foam core or white drawing paper. Here are a few fun games to play for the sake of enhancing your creativity.

While watching TV—which will distract your left brain—cut images or words that you like out of newspapers, junk mail, magazines, or whatever else catches your eye. Do this part without much thought, purpose, or pressure.

Now take these pieces and arrange them on a large (3ft x 4 ft) piece of black foam core which you can get at Staples or art store,core. Don't have foam core? Then use the floor, or a table. If you need less space paper will do.

There are no rules—play with the images and arrange them in a way that you find pleasing. Images can extend beyond the edge of the paper, and they can overlap. Just have fun, observe what you like and what you don't like without judging. You can keep adding additional images, and delete the ones that don't work. You can keep rearrange the pieces as often as you like—just because. Now you can either glue the images down, put them away to reuse another time, or leave them in place. All of these exercises are meant to help you be more observant, and to see the beauty in all things.

Another way to enhance your creativity is through mindfulness. For example, take a walk outside and take photos of things that you would never have ever bothered with before—like a close-up of a piece of tree

bark, a dead leaf, an interesting rock, or anything else you notice, but have never really seen before.

Part of enhancing your creativity is learning how to see the beauty in all things. Here is a fun, effortless exercise you can do over and over again. Take a few close-up pictures of the fruit and vegetables you eat. Here is the catch—you need to photograph both the part you eat, and

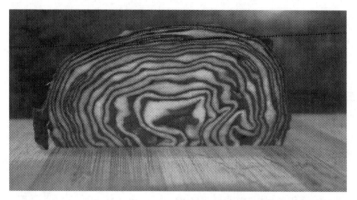

the pieces you generally cut off and discard. Take a moment to see the real beauty in everything, and give thanks for the contribution the food makes to your health.

Doesn't the center of the second photo look like a pair of woman's lips? It does to me.

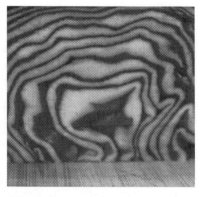

I am always amazed by the beauty of everything when I look at each item up close and from different angles. Today I was making a red cabbage salad for a friend. The first thing I did was to remove one wilted outer leaf and set it aside. After

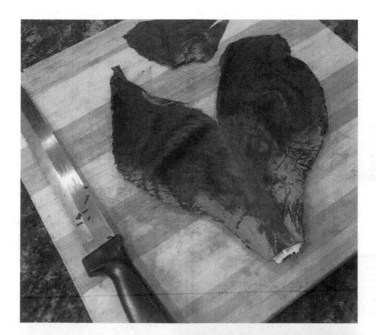

the salad was made, I looked at the outer leaf that I was ready to throw away.

Then instantly, guess what I saw? To me, it looked exactly like a wolf's head, eyes and all.

Why was this amazing? First the name of my company is **Red Wolf Design.** Look at the necklace of a wolf's head to the right. While I hadn't seen it for years, suddenly it reappeared three days after I made the cabbage salad. Pretty cool!

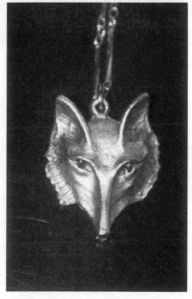

There was one more thing I noticed when I tore off the outer leaf. A green section of the leaf appeared as if the actual leaf was made of two layers. Take a moment to notice the beautiful pattern of veins, the contrast between the purple and the green, and the interesting texture—again, things we generally don't notice. Didn't this little exercise make you stop, be in the moment, and take time to really see things that we never really look at? Hopefully, this activity will make it more difficult to pass things by without acknowledging their presence, saying hello, and complimenting them on their unique beauty. I will keep this our secret—at least for now.

The only reason I noticed the soon-to-be discarded leaf was because I took the time to really look at and appreciate the leaf, and decided to photograph it. See how taking a few extra seconds while doing the mundane can open new worlds of miracles and magic that are so easy to overlook?

Many people don't think of themselves as artistic or creative. Want to know why? It's because they mistakenly assume that if they can't draw or paint, they aren't artistic. How and why do people make this assumption? It may be based on a limiting belief which is formed at an early age. Or, just as likely, it can stem from a child's comparing their work to the teacher's work or to the work of the most "naturally talented" classmate.

Unfortunately, once children start comparing, judging, and labeling their work and conclude it is no good, that belief can linger on, often far into adulthood. This underlying belief is frequently reinforced by a lack of encouragement and/or praise from parents and teachers alike. In some cases, other children may make fun of their classmate's work—not necessarily because the work is awful, but rather because they just don't like the child.

Here is a magic concept that can change your life in an instant.

It is not until we really
stop judging, comparing, and labeling
ourselves, others, events, and situations,
that we can truly be conscious that we
are all one and can be truly happy.

Adults can hold onto these beliefs, concluding that because they can't draw or paint they are neither artistic nor creative, so why pretend otherwise? **Why risk criticism or failure?** It is often fear of criticism that keeps people from being their true authentic, beautiful, creative selves.

The good news is that, instead of being doomed by this limitation, you can realize that the ability to draw can be learned. Or you can simply give yourself permission to do your own drawing without learning from others.

The simple act of learning to draw will give you the confidence and momentum to explore a range of exciting media such as colored pencils, watercolors, acrylics, oils, pastels, etc. Just playing with art supplies as a means of self-expression can help you rediscover your long-lost creativity. You can even start out with finger painting. You may be stunned at how good you are and at how much fun you can have. Always remember—**having fun is essential for reconnecting with your inherent creativity.**

Recently, while attending a conference, I started sketching my favorite subject—imaginary mountains using a pad of yellow ruled paper, a ballpoint pen, and a pencil. After I made this simple sketch I put my finger in a glass of water to see if the pen's ink would dissolve enough to create some sense of shadow, and it did! Here is my picture.

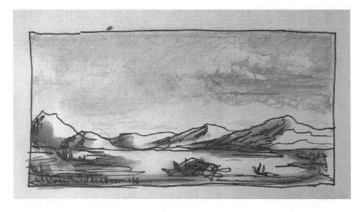

Then I remembered I had a few graphite pencils with me which I used to create the sky. Remember I already confessed that I love shopping, especially in art supply stores—**but you can create the same look with any pencil.** To make clouds use a pencil. First make light circular strokes that look like clouds. Next using the heat of your finger and rub the lines in the shape of clouds, the graphite will blur and clouds will appear.

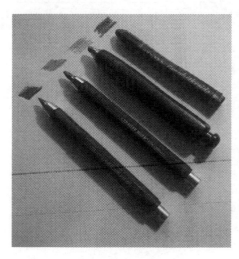

Here are my graphite pencils. You can see that each holder has a different type of graphite or lead— from soft to hard.

Below are three graphite pieces that fit into the holders. Why not use pencils? Because you have to sharpen pencils. Plus, these graphite holders are much cuter, and without the holders the lead would break. The lead comes in different hardnesses as you can see in the first photo.

I did the drawing on the next page in about three minutes during the same conference of over three hundred attendees. What made it fun was that I did it using only a black roller ball pen, a graphite pencil, and a finger, which I kept damp by repeatedly dunked it into a glass of water.

The most enjoyable part was the fact that I made up the technique for creating the shadows. Just as I was ready to put the sketch of my imaginary mountains away, the person next to me commented on how good it was. I smiled and thanked him. Back in my hotel room, I looked at it again and thought, yes, it was good. Why? Probably because I had fun doing it using my new, very special wet-finger technique.

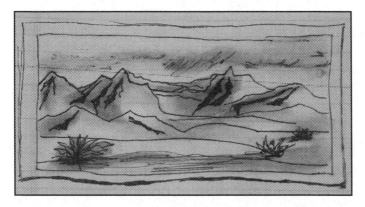

Would it surprise you to know that I love almost everything I draw or paint? Does that seem strange?

It probably does to most people, but not to me. That's because I have two unusual beliefs that I know to be true. First, I know that the creative spirit of love and light from the Universe is doing the work through me. Now if I don't like my work, it is an insult to God and that would be terribly rude! Second, I appreciate that only I could have created this image at that moment in time. This removes the notion that the drawing should look a certain way, and eliminates judging, comparing, and labeling this little drawing.

So next time you decide your artwork is terrible, remember that only you could have created that exact piece of artwork at that exact moment in time—and if your painting looks like a child did it, remember that is a very good thing.

Do I hear anyone out there thinking art supplies may be a tax deduction? Yes, I think that may be a possibility.

What do you really believe? As I have said, many people have self-limiting beliefs about their artistic abilities, which really have deeper implications.

If you want to know more about your belief system, take this one-question quiz. Pretend that a good friend invites you over to draw or paint with her. What do you say?

- Sure, that sounds like fun—because you enjoy drawing or painting
- No way! Are you kidding? I can't even draw a straight line
- Sure, but qualify your acceptance with a statement like—I will probably be terrible since I haven't done any painting since I was a kid and even then I wasn't any good
- Or do you say, sure—because you are one of those nice people who can't say no

For some strange reason, many people cringe and recoil at the mere invitation to paint with me—as though they were being invited to try fried crickets—and they often have a need to explain that:

- They were never good at art—a belief based on comparing themselves to the "naturally talented" kids in the class
- Their teachers or parents never encouraged them
- They were discouraged from pursuing a career in art because "you can't make a living at it" and "you will never be a famous artist."
- They have never really tried drawing and don't want to waste time doing something they "know" they won't be good at
- They see themselves as artistic in other arenas, but have no interest in drawing or playing with paints or pencils

Just like any other skill, drawing can be learned.

Think about it. No one expects to pick up a guitar and play well without taking lessons and practicing—right? So why should the ability to draw be different from mastering any other skill, whether it be playing an instrument or playing a sport?

The real questions may be:

- Why do you think you have to be good at everything you try?
- When did you stop giving yourself permission to play?
- When did you forget how much fun exploring and learning is?
- When was the last time you consciously decided to be spontaneous, in the moment, and detached from outcome?
- Does taking a risk scare you?
- Are you judging, labeling, or comparing yourself to others?

Just try drawing anything for two minutes. In Edwards' workbook for *Drawing on the Right Side of the Brain*, she writes, "I guess that the biggest difficulty you will experience in working through these pages is finding the time to draw."

She continues, "It rarely works to tell yourself that you will draw for an hour each day, or even an hour each week. The commitment of that much time will probably seem daunting. Remember that your left brain, the verbal/analytical side does not want you to draw at all, because it is 'set aside' while you are drawing. The language mode is very good at presenting reasons why you should not draw—you need to pay the bills, call your mother, answer your emails, or just tend to whatever other business is at hand." She added:

> "Once you actually 'get into' drawing, however, time passes seamlessly and productively."

72

Ms Edwards recommends that you tell yourself you will only draw for two minutes, because frequently that is all the time it takes to get into the flow or zone where the sense of time actually disappears.

Still not convinced? If you are still somewhat resistant to attempting to draw or paint, here is an exercise that may give you some invaluable insight regarding your limiting beliefs. Read the instructions all of the way through before you try it. Or record yourself reading the copy and then listen to the instructions with your eyes closed. Remember to pause in between bullets so you will have time to visualize each part of the exercise.

- **Imagine you are alone in an art studio**
- **Look at a clock in your imaginary studio**—see the clock
- **Notice the time. What time is it?**
- **Visualize yourself standing before a large, sturdy easel** Notice that the white smock you're wearing has a rainbow of brilliant colors smudged on it. The canvas on the easel is exactly the right size.
- **There is a table all set up** with all of the brushes, paints, thinner and rags you will need, and you know how to work with all of the supplies.

- **You know exactly what you want to paint.** It may be an original idea or an image from a photo that you want to capture
- **You are ready and excited to get started**
- **See what medium is spread out for you.** Is it acrylics or oil paints?
- **Hear your favorite music playing.** If it is not loud enough, see yourself making it louder.
- **Feel how much pleasure you get out of squeezing paint** onto your palette and then mixing the colors you want to use without a moment's hesitation.
- **Appreciate how much you enjoy painting** and experience feeling in a state of flow.
- **Notice how "at peace" and relaxed you are**, knowing that the mundane chores of life and work are handled . . . impeccably.
- When you are done, step back and look at your work.
- **Feel yourself loving the painting** and being surprised at how fabulous it looks. Visualize it framed in just the right frame.
- **Now go back to the painting and date and sign it** and remember to keep smiling.
- **Look at your imaginary clock again.** How much time has passed?
- **Now envision how proud you feel** as you show your framed artwork to a friend or spouse—with little regard as to what they think.

What is important to you is that you liked painting, had fun creating and know that it enhanced your creativity.

See? It is that easy to imagine the joy you get from giving yourself permission to paint without judgment or self-criticism.

Exercises like this one are incredibly powerful. Research has proven just how effective they are in those domains where results can be quantified and measured—such as sports. Many research studies have shown that athletes who visualize themselves exercising or practicing a sport do as well as those who actually exercised and practiced.

Does time really matter? How much time did you visualize yourself spending on your painting? That may be symbolic of how much time you allow yourself to be creative—to consciously enter the world of your imagination. Next time you try this exercise, visualize yourself spending several hours in imaginary time. Notice how that feels and how it affects the quality of your finished product. Do these suggestions of time affect how you experienced the exercise?

Did you get any interesting insights from the exercise? It was designed to help you identify any artistic blocks you may have, based on how you answer the following questions:

Did you like your artwork? If you didn't like your work, see Number 1 below.

Did you find yourself comparing your work to that of a famous artist? If yes, read Number 2.

Did you label your work as ugly, or terrible? If yes, read Number 3.

1. **If you didn't like your work,** this can mean you are being too critical or judgmental. Try the exercise again, only this time visualize your final piece as really extraordinary. How does that make you feel? Since you are in charge of your imagination, thoughts, and feelings, you get to create a reality that makes you feel creative and wonderful. Remember that your imagination and thoughts create your reality.

2. **If you found yourself comparing** your work to that of a famous artist, consider this: Is there any reason your artwork should look like someone else's? Probably not—unless you're a professional forger!

3. **If you are labeling your work as ugly, or terrible**, remember that labeling is another form of comparing your work to someone else's. It is also a way to quickly dismiss the quality of what only you can bring to the party. So just stop it.

Judging, comparing, and labeling are types of thoughts you should be aware of and avoid doing because they can be upsetting, prevent you from coming from your own authentic self, and can make you cranky.

Here is a good way to re-frame painting. When I paint or draw, I never have a specific outcome in mind. For example, I may think I want to create a landscape and here are some of the colors I want to use. After all of my supplies are neatly arranged, I take a minute to absorb the beauty of the colors. I give thanks for allowing myself time to paint. Then I put on my favorite music, turn my left brain off and give my right brain time to play, explore, experiment, and have fun. This puts me in the moment.

I am always surprised by what I create, and am usually pleased. That is because when I paint, I feel I am just a conduit through which energy from the Universe, my ancestors, angels, or my higher self flows. That's because it's easy to connect to Source just by bypassing my ego and left brain.

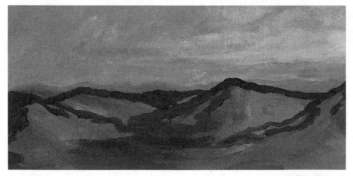

Lynne Evan Hoinash

Here is a painting of "my mountains," I started and stopped once I added the thick dark purple outlines. I stopped to let it dry overnight, intending to fix the dark purple lines the next night. The next day I decided that I liked the weird thick lines even though they didn't make sense. Then I declared it finished, signed it, dated it, and decided to frame it.

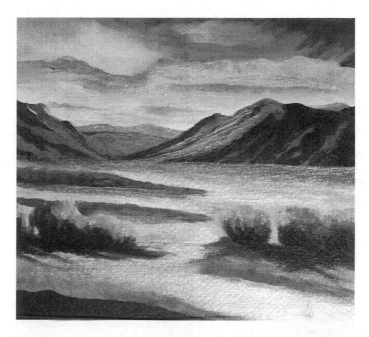

Honoring what I produce is an important aspect of my process. When I think of myself as an instrument the Universe uses to create, I appreciate that only I could generate that exact image at that very moment in time. That is really the inspiration or talent from the Universe.

So be in the moment and observe the process. Did you take a moment to appreciate how many people and elements from the Earth were needed to produce just that one tube of paint? When you come from gratitude throughout the process, trust your intuition, and let the left side of your brain relax, the more fun you will have. So never be displeased with your work, just think of it as a collaboration with the Universe. If someone doesn't like it that is perfectly fine. Do what I do and say, "That okay, it's part of my early works," which will become much more valuable over time.

Think about it. When someone dislikes his or her work, it is like disparaging God's work as well—not that he or she cares.

Just recently, I was totally amazed by something that occurred. I was working with a ten-year-old boy, Aiden, who created a fabulous portrait of a woman on a sheet of 8" x 11" paper. When I went to frame the painting for him, I realized that the only picture frames I had in my studio were for 5" x 7" images. So I placed the piece of glass from the 5" x 7" frame over his painting and let him move the glass around until he found a portion of the picture that he liked best. We cut out that piece and once he signed and dated the piece I framed it for him. The partial face looked smashing framed—very mysterious and much more dramatic than if the entire face were framed. Here is a crude version that I did, but you get the point.

Whether I love the artwork I have created or not, I date and sign it. Next I frame it, which dramatically enhances the overall effect. So you may want to start buying inexpensive frames in difference sizes that are on sale from Michael's just so you have some on hand so framing your new artwork doesn't involve an added step of buying a frame.

You will be surprised how important it is to have frames on hand. Without having spare frames to choose from, many pieces of your work may never get framed and you will miss seeing how professional even a simple line drawing can look with an inexpensive frame.

When doing artwork with kids, I do the same for them. After they've dated and signed their art, I frame it. Now they have something to take

home that has been "officially" deemed frame-worthy, which they can show off with great pride. You never know, this may be the start of a career.

This also reinforces the idea that they are talented and creative—a belief I hope stays with them for life.

An idea worth sharing— several years ago I was a big sister, a part of the Big Brother/ Big Sister Program of Mercer County, NJ. Before I framed any of my little sister Chelsea's work, I would get two color copies made so I could have a framed copy and she could give one to her Mother to display. Every time Chelsea saw her work prominently displayed in my office I would catch her smiling and nodding her approval. Here is my copy of Chelsea's first drawing which I will always cherish.

Having your artwork professionally framed is really expensive and not necessary. Off-the-shelf frames are great because they help keep your "early works" safe and wrinkle-free and can be used for framing more recent works while still keeping your earlier pieces safe behind the newer image.

Conversely, when you have frames custom made, the framer will add a piece of brown paper to the back of the frame to keep out dust and before attaching the hardware. Now if you want to reuse this frame you have to first remove the hardware, destroy the backing paper and reconnect the hardware—which is way too much work for me. But in fact it is easy to do.

How to be detached from expectations. When I don't like what I paint, I don't get upset or frustrated. I am grateful I had the time to paint, was in the moment, and was not attached to outcome. Instead of throwing the painting away, I put it aside because I may want to continue playing with it later. Since it is in the "not yet fabulous" pile, I can use it to experiment with techniques I might not explore if I were starting with a new canvas.

One of my favorite sayings, which I either made up or read is,

Everything is always perfect,
even though I may not see
the perspective
from which it is perfect.

Appreciation

For me painting is an opportunity to be grateful for every person involved in the supplies I use, and can easily take for granted. When I remember to be thankful for everything, and I mean everything, I begin by sending love to the end products: the paints, the canvas, the brushes, the thinners, and to all of the various the supplies I use. Next I send love to all of the people who designed, manufactured, packaged, and shipped these supplies to me. But I don't stop there. What next you wonder?

Next I send loving gratitude to all of those people who built the machines that were used to create these items, and to those people who designed and built the buildings where the items were made. I send love, and appreciation to the trees that were used to make the brush handles and canvas frames. But that is just the beginning.

I send loving gratitude all the way back to Mother Earth. For the trees used, the soil, and for her nurturing of these trees. Then back up to Father Sky for the sun and the rain. I thank the earth for the clay to make

the bricks used to build the building, and to the steel ore used to make the machines,I can go on and on. I find this to be a very centering process that takes less than fifteen seconds and always leaves me feeling so blessed. Try it sometime. It works miracles, especially when you are in a bad mood. Did I mention that you can also thank the people who generations before our generation created earlier versions of each element? You see how this really awakens our awareness that we are all connected by the hard work and vision of those who came before us.

Not yet overwhelmed with gratitude for everything we take for granted? The next time you see a painting by one of the great masters from hundreds of years ago, realize that those artists had to create the paint and varnishes they used working with raw pigments and binding materials that came from all over the world. They also made their own brushes out of animal hair, built painting surfaces and frames by hand, and they could only paint by sunlight since the light bulb was not yet invented.

Here is an easy way to begin

I made this technique up while playing with children, but adults enjoy it just as well, if not more so. First I draw an outline of a face with the neck, ears, and an indication of the placement of the eyes, nose and mouth.

Next I use powder bronzer make up to begin creating the shapes and contours around the face and for the nose. Here is my secret technique—I take a finger or two and rub it across the surface of the compact and just begin

creating the shadows and details. Using a roller ball pen, or fine-tip Sharpie, I continue to add more details and shadows.

With a thicker Sharpie, I create hair in about thirty seconds. All you do is to start at the top of the head and quickly create lines and waves to the length you want. Next I sign, date, and frame the drawing which probably took less than five minutes to create.

Try using a frame that is smaller than the image. This way you can move the frame, or the glass from the frame around over the drawing to decide which cropped section is most interesting. Just be careful not to smudge the image.

Where does inspiration come from? Everywhere, and not just from your imagination. A piece of trash might make a great canvas, or the shape of a dead leaf may catch your eye. The more you practice mindfulness, the more your creativity comes alive.

Once you declare that you are creative, all sorts of ideas will come— some mundane and some positively groundbreaking.

Where to begin? *methods and materials*

If you are feeling clueless, that is fine. Here are a few suggestions for getting started. First, decide your level of interest and which medium appeals to you—graphite pencils, colored pencils, markers, charcoal, pastels, watercolors, acrylics, or oils, just to name a few.

Look around your house or office and see what art supplies you have. A pen, pencil, highlighter, and paper are all you need to get started.

Next, decide how much time and money you want to spend on art supplies. And finally, decide what size art you want to create—you can start with a doodle or Zentangle (keep reading to find out what this is), which is done on a 3 1/2" x 3 1/2" piece of paper or any other size on up.

Here is a brief overview you may find helpful.

Drawing

The obvious and least expensive route is to pick up any pencil you have. A #2 pencil is great. Grab a piece of paper—it can be the back of an envelope you are ready to discard—and start drawing absolutely anything. You can draw a leaf, a mug, a face, etc. It doesn't matter. Draw or doodle while watching TV, and just see what images appear.

Next you may want to go to Google or YouTube. Typing in the words, "how to draw" opens up a window with an entire list of options, including how to draw very specific things, such as: a rose, clouds, or a dragon.

Once you select what you want to draw, you'll get another list of videos on that exact subject. Once you choose a subject, briefly view several videos until you find one that you truly resonate with or love. Life is truly amazing, in part thanks to technology!

I picked "how to draw a face," and found tons of options. Next I randomly selected "Face tutorial," by Everything Mary, which was great! As she drew, she clearly explained the techniques to create a realistic-looking face. The video is only 9:25 minutes long—perfect. After a second or third viewing, I was ready to draw along, having learned the basics firsthand.

Doodling

If doodling sounds just right, again you can just start doodling without any specific supplies. For some people, doodling can be easier while watching TV or listening to music. Again, there are hundreds of samples of doodling on Google worth looking at for inspiration. But just to begin, you can use shapes, words, random lines, or whatever else naturally appears.

Doodles can also be little quick sketches like the ones below. The two black and white drawings—the eye and the cartoon character—were done by my graphic designer and friend, Kevin Lee. He created both in less than four or five minutes. I drew the vase with a flower.

Almost everyone is familiar with doodling—especially if you have ever been on hold waiting for tech support, sitting in a tiresome meeting, or trapped in a conference when you would rather be playing golf. You can doodle almost anytime and anywhere. It is fun, relaxing and enjoyable.

Whereas in the past we tended to think of doodling as a total waste of time and materials, we can now see it in a whole new light. Thanks to Betty Edwards' research and books on drawing, we are able to appreciate the fact that when we do any form of artwork, including doodling, it helps us switch from left brain to right brain dominance.

This is a major coup because the left brain is a control freak and wants to be in charge of everything all the time.

Did you know that doodling relaxes us? It's a fun, fast and totally spontaneous way to play—letting lines, shapes, curves and squiggles come to life. Save your doodles, noting the time, date and place where each was created, along with what you were thinking about and the mood you were in. Oftentimes your doodles may give you the insight you need to see a situation in a new light. You might like to buy an unlined notebook that you keep with you and only use for doodling.

Here is an interesting experiment you can complete in less than three minutes:

- Think of a person, place, or pet that you love and then create a doodle of anything. Are you smiling? Did that make you happy?
- Now think of someone or something that makes you mad or upset. Create a second doodle. What a difference, right?
- Draw a big X through the second doodle, the one drawn when you were thinking about something upsetting. The simple act of crossing it out may help to defuse some of the drama around the issue.

Another advantage to doodling is that there is no pressure to produce a specific product. Doodling is probably the most accessible form of art we can explore. There is a series of excellent books on doodling by Stephanie Corfee. You can buy her *Creative Doodling & Beyond* kit at stephaniecorfee.com, at Amazon.com, or at BarnesandNoble.com. All you need to start is paper and a pen or pencil. Stephanie also has a three-minute video on her site that teaches you how to create fun doodles.

An article in the October 2014 issue of *First for Women* magazine, **"Boost Creativity with a Doodle,"** says, "The next time you need to find a solution to a problem, take a minute to doodle a few triangles with points that reach toward the top of the page. Psychology experts say triangles symbolize self-discovery and revelation, while the upward points signify direction toward a goal—so this sketch delivers instant inspiration to help you come up with a fantastic idea in a flash."

Want a different kind of inspiration? Great! Go to the children's section of your local library and find a few books where the illustrations make you smile. Check them out and use them to create your own version of the artist's work.

I did just that. The two books that I LOVE are *Matilda's Cat* by Emily Gravett and *Posy,* which is written by Linda Newbery with Catherine Rayner's whimsical illustrations. I so love these books so much that I bought a used copy of each on Amazon. Just opening either book to any page makes me happy! Life doesn't get much better.

Here are my two paintings based on the illustrations in the books.

Want more structure? So you are convinced of the value of exploring art to enhance your creativity, but your very-determined left brain wants to stay in control. No problem. There are four options below that will trick your left brain into relinquishing control, giving your right brain a chance to come out and play. Don't smile too much when you play with any of these tools, because your left brain may get suspicious!

These tools are all easy to play with and master. They provide an opportunity to learn something new, are all inexpensive, satisfying to work with and stimulate creativity. There are more free instructional videos on YouTube.com and on the sites mentioned, if you want to learn more about each. All four take very little time to try. Further, the tools are easy to transport and fun to share with others. You can also pass them on to your colleagues, children, or grandchildren once you are ready to explore other mediums. But chances are you won't want to give anything away.

The following tools and techniques are perfect and you've probably heard of at least one of them. You can begin by:

- Creating a Zentangle®—zentangle.com—more info to come.
- Working with a Spirograph®—amazon.com offers many sets.
- Using a coloring book—there are hundreds on the market for adults.
- Coloring in mandalas—mandalas are a popular design theme from the Buddhist tradition. For free prints from your computer, go to printmandala.com.

Zentangle is an approach for creating art based on drawing repetitive patterns on a piece of paper. You can find free instructions and sample patterns on-line. This makes it easy to try the Zentangle method of doodling before buying any of the official books and supplies. To start, you simply draw a 3.5" square, or print one out using Word or any design program. Use any black roller ball pen, gel pen or extra-thin Sharpie for drawing the design.

The benefits of Zentangle are many. It reduces stress, helps you focus, and enhances your creativity and imagination. Not only can this relaxing approach unlock your innate artistic talent, many think of it as a great form of meditation. All you need to get started is a sheet of paper, a black marker and a design. The supplies are tiny and portable—another advantage. There are also instructional videos, such as "A Creative Way to Meditate" and "*Zentangle Basics*" at JerrysArtarama.com and on YouTube.com.

Spirograph® offers a method for creating amazing geometrical designs using a set of interlocking gears and wheels. Does that sound boring or simplistic? Just Google "Spirograph" and click on "images" to see the amazing results that are possible. As you scroll down through the images, you'll see some created in black and white, others that used different colored pens and several that were colored in with pens, pencils, or markers.

The Spirograph was originally developed for use as a drafting tool. It combines the principles of art and mathematics. I included this fact to make your left brain happy! The toy was introduced in 1965 and was just reintroduced in 2013. It comes in several versions and is available on Amazon.com and in toy stores.

Once you have created your own unique pattern, you can then use colored markers, pens, or colored pencils to add your own creative touch. You can order any number of sets on Amazon.com. I just found a cool new Spirograph app—still in its early stages of development, which you can preview on YouTube.com. Search, "Amazing Spirograph app—"Vibrates Phone and Draws." It's fun to watch, so I won't tell you any more than that.

Coloring Books—Today there is a whole array of coloring books for both children and adults. The coloring books designed for children are great fun and come in a multitude of themes, from animals to spaceships.
Another book I love, since it is about both doodling and cats

is *Doodling for Cat People* by Gemma Correll. I just happened to bring the book, along with paper and pencils with me when we went out to dinner with my granddaughter Isabelle and my son-in-law, David. Isn't that a sneaky way to get free artwork from Isabelle! We all enjoyed drawing and a great source for conversation. Here are her pictures.

Coloring books for adults are better than ever—and they do exist! Some contain realistic images, while others are comprised of beautiful designs. Some of them even come with a DVD, so you can print out multiple copies of the same design. Try coloring multiple versions of the same design on different days—it's always interesting to see how the colors you choose are really a reflection of your mood, thoughts, and attitudes at that moment.

One of my favorite mandala coloring books is: *Everyone's Mandala Coloring Book Vol. 3* by Monique Mandali. Her entire series are fun.

In Sanskrit, mandala means circle and signifies wholeness, unity, and our connection to infinity. Mandalas are created as a means of entering a profound meditative state, in which your mind goes within for greater self-awareness and discovery.

What are mandalas? In Sanskrit, the word also can mean "essence (of the Universe or soul) within." Buddhist devotional images—symbols of the ideal Universe—are often used for meditation. Mandalas can be painted, drawn, or made using sand.

If you want to see what other mandalas look like, just Google "mandala images." You will see that these intricate geometric shapes are amazingly beautiful and unique. They are first drawn, then each line and negative space is either formed or filled in using a range of brilliant colors. Creating a mandala with sand can take several people many days to complete and requires a high degree of concentration.

You may have seen photos or documentaries depicting Buddhist monks kneeling on the ground or standing around a table that has an outline of a mandala. If not, to watch this amazing process search YouTube: Tibetan Sand Mandala—Time Lapse—Asheville, North Carolina -Urban Dharma- GRAND PRIZE WINNER. When the mandala is completed, the sand, which is not glued in place, is ceremonially brushed into a large pile, put in a container, transported to a body of water, and poured into the water. This is a symbolic act of spreading blessings to all.

When you begin coloring a mandala, you almost instantly fall into a meditative state, a state of enhanced creativity, which is very peaceful and helps to reduce stress.

If coloring mandalas seems intriguing, go to Google and type in "free printable mandalas for coloring." You will find a host of free designs. Or go to printmandala.com and scroll down through the panel of mandalas on the left side of the home page to see even more designs. If you are enjoying this process, you will find over twenty pages of mandala coloring books, along with color markers, on Amazon.com. You can also use colored pencils, crayons, markers, ink, acrylics, glitter, or colored gel pens.

Want to try drawing? Here is a partial list of drawing and sketching materials you might want to try. These items are sold both individually and in kits of varying sizes.

- **Graphite pencils**—a set includes between six and twelve pencils
- **Colored pencils** which come in both watercolor and as pastel pencils.
- **Liquid graphite** which comes in a variety of hues
- **Charcoal** is also a great way to start

Once you decide on the type of drawing tools you want to try, make sure you buy the right type of paper for the medium you chose. Again, the choices are endless. Never hesitate to ask for help in an art supply store, or to call the customer service department if ordering from an on-line catalog.

Want to try painting?

The three most popular mediums to consider are watercolors, oils, and acrylics. They each have a unique and distinctive look, so you may want to select a medium based on how much you like the end results. It is always helpful to know the pros and cons of working with each medium.

Watercolors, oils and acrylics all come in two grades—professional and student grade. Obviously student grade is best when just getting started because it is less expensive. Generally, one of the biggest differences between the two grades is that the student grade has a lower concentration of pigment (the color) and more binder. Sets are less expensive, and will generally give you the best set of colors needed to make most of the colors you'll need to get started.

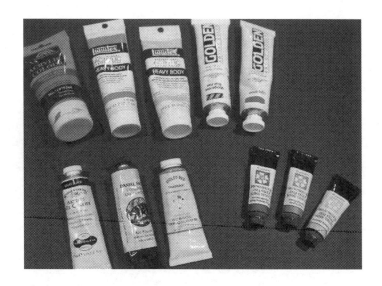

Above is an example of the various types of paints. The top row is acrylics made by several different manufacturers. On the bottom row, left-hand side, are tubes of oil paint and on the right are tubes of watercolors. You'll notice how much smaller watercolor tubes are. Watercolors also come in small square pans.

Watercolor

Pros

Watercolor paints come in small, lightweight tubes and cakes or pans, which are easy to transport and ideal for working outdoors. You may be familiar with the commonly used expression, *en plein air*, a French phrase that refers to painting outdoors. You can begin painting indoors or outdoors with a limited amount of items: paint, paper, brushes, a palette, jars, paper towels, and water. Watercolors can be done quickly and they dry quickly, which is a real plus. Easy cleanup is also a major advantage. You only have to use water and a special soap for cleaning the brushes. When watercolors are used masterfully, the results can be spectacular.

Cons

Watercolor can be a surprisingly difficult medium to master for various reasons. The paint dries relatively quickly with or without the aid of a hairdryer. Unfortunately, the colors you see when painting can be deceiving because as they dry the brightness diminishes. Since the colors will look more intense, brighter, and more vibrant while the paint is wet, once dry they become lighter. Mastering watercolor painting includes learning how much lighter each color will be when dry since they are not consistently duller as they dry. The next challenge with watercolors is controlling the movement and flow of the paint, especially if the paper is too wet. Unlike acrylics and oil paints, you can't paint over an area that you don't like. All you can do is run the watercolor paper under water and try to wash the color off.

What do you need to know about watercolor paper? There are three types of paper surfaces to work on ranging from rough, medium rough, to smooth. The paper generally comes in two weights or thicknesses—140 lb. and 300 lb. The weight is based on how much 500 sheets (or a ream) of the paper weighs. You can purchase watercolor paper as a single sheet or in pads. In either case, the individual sheets of paper have to be taped down to a drawing board to prevent the paper from buckling. Watercolor paper is also sold in blocks. The blocks are the most convenient to use—the paper doesn't buckle because it is glued down on all four sides and attached to a hard cardboard support. The paper is kept attached to the block until the work is totally dry. Then it is sliced off from the block with a paring or X-acto knife.

Acrylics

Acrylic paints are sold in various tube sizes, in jars, in squeeze bottles, as ink, and as markers. The paint comes in two viscosities—heavy body and soft body. You will find that different manufacturers have many of the same colors as well as colors that are exclusive to them. Liquitex, as an example, makes a range of unique products: decorative colors, fluorescent colors,

iridescent colors, and something called interference colors. As acrylics come in so many colors, they present an endless range of possibilities that are really fun to explore. The paint tube displays important information about each color, including size, color, series number (the higher the number, the more expensive the paint), whether the color is opaque or transparent, etc.

This medium uses paper and brushes designed especially for acrylics. Other tools you might want to experiment with are rags, paper towels, spray bottles of water, jars for combining different colors, a palette knife for mixing colors, and masking or drafting tape. There are also glossy and matte varnishes that you can use during the painting process, or once a painting is done. These varnishes will give you very different results—either a gloss or a matte finish.

Pros
The advantages of selecting acrylics are:
* The paint dries quickly

- Paintings can be completed in under an hour
- You can paint over areas you don't like when those areas are dry
- They are generally less expensive than oil paint
- You can paint on canvases, canvas boards and various papers that are especially designed for acrylics
- Cleanup is easy

Cons

There is only one disadvantage of selecting acrylics—the paint dries quickly on your painting, palette and brushes. While drying retardants are available, the medium still may dry too quickly for you.

Oil paints

Oil color paints come in small and large tubes almost identical to acrylics.

Pros
- The advantages of selecting oils are:
- You can create amazing effects with glazes and mediums
- You can paint over areas you don't like once those areas are dry
- You can buy water-based oil paints, which dry more quickly
- You can paint on canvases, canvas boards and even regular paper as long as you thin the paint using a solvent such as Gamsol.

Cons

The drawbacks are:
- Oil paint takes a long time to dry—which varies based on the thickness of the application of paint, the color of the paint, and the weather
- Many of the paints and solvents can have a strong odor
- Cleanup takes much longer
- Some of the solvents required for thinning paints and cleaning the brushes can be toxic and dangerous to have around, especially if you have animals or small children

In all three types of painting there are specialized brushes to choose from, and using the right brush can make a difference. There are even brushes designed for painting a person's or animal's hair—who knew? It's fine to buy inexpensive brushes in the beginning that can be used for multiple types of paint

Again, don't be overwhelmed by the limitless range of options. Just ask for help in the art supply store or call a manufacturer's customer service if you want more specific information on their product. These people can recommend the brand a beginner should buy, which colors are necessary, which colors are easy to mix with the colors you are already buying. You can also view video demos that art supply catalogs and manufacturers include on their websites.

Types of paper

Just as in every area of art supplies, there is an overwhelming selection of paper choices. There are drawing pads, drawing books, sketch pads and sketch books. When you first start drawing, any paper surface will work fine. You can use copy paper, lined paper, a paper bag, or the back of an envelope.

When you decide that you want to start drawing or sketching on a regular basis or want to save your work, you have many options of types of paper to use. Initially, I found the options staggering until I learned the difference between a sketch pad and a drawing pad. Here is what I found out—sketch pads/notebooks have thinner paper, whereas drawing pads/ notebooks have thicker paper. The thicker paper is preferable if you want to frame or save your drawings.

There is an easy way to compare the thickness of the paper (besides feeling it). On most all pads and notebooks, you'll see the number of sheets the pad contains along with the weight of the paper such as: 60 lb., 98 lb., 140 lb., or higher—the higher the number, the thicker or heavier the paper. There are two advantages of using heavier paper. It is easier to erase unwanted lines without the paper wrinkling, and if you tend to press hard when you draw, your graphite or colored pencil won't leave indent marks on the next page. Both pads and books now come in a variety of sizes and shapes—horizontal, vertical, and square.

Even though I do quick sketches, I prefer the heavier weight paper and am willing to pay a little more for that indulgence! It is important to buy a pad that you use exclusively for drawing and not for other things such as writing out your to-do list. Keep your sketching pad in your car or somewhere you can easily access even when traveling. I keep a pad next to the couch where I watch TV. This is a great time to draw—especially when the show is boring, and during commercials.

All types of drawing surfaces are available in all different sizes, so you might want to buy a large pad or book for serious sketching and a small one that can fit in a pocket or briefcase for spur-of-the-moment drawings.

I also recommend that you buy a Faber-Castell 9000 Graphite Pencil Set. It comes with twelve pencils in varying degrees of darkness and hardness, a sharpener, an eraser, and a cloth bag that everything fits into.

This set costs around $20.00 and each set has pencils ranging from 2H to 8B. It is a fun way to learn what the notations on each pencil indicate.

Keep all the drawings you do, so you can see the different aspects of your evolving style. And remember to have fun!

How to learn even more about art supplies and techniques. There are many ways to learn about the various types of painting and drawing supplies that are available today. One of the best ways to educate yourself is by going to a good art supply store where you can actually see, touch, and try the materials before you buy them. The staff generally consists of artists who can give you invaluable advice and can help you select the best products.

If you don't have an art supply store near you, you can order supplies on-line. Even if you do have a store in your area, it is fun to visit the discount art supply websites listed below. These sites not only provide helpful information about all the products they sell, you will find many items that, due to lack of space, are not available in their retail stores.

All of these sites provide links to instructional videos because the manufacturers of all these art supplies have a vested interest in helping you learn how to use their products. Furthermore, they want to familiarize you with all of their ancillary products—those that extend beyond the basics.

My favorite websites are:

- JerrysArtArama.com
- DickBlick.com
- DanielSmith.com
- CheapJoes.com
- aswexpress.com

Another way to educate yourself is to go to Barnes & Noble and purchase a few art magazines in the medium to which you are most drawn. There are specific magazines for the each of the major media, such as:

- *Acrylic Artist*
- *American Artist*
- *Artist's Sketchbook*
- *Colored Pencil Magazine*
- *Drawing*
- *Pastel Journal*
- *The Artist's Magazine*
- *Watercolor Artist*

These publications feature great how-to articles, websites worth exploring, dates and information about upcoming classes/workshops nationwide, along with award-winning art work you'll find inspiring. I especially enjoy reading the ads in these magazines—where the latest materials, equipment, and books are promoted, along with special introductory product are offered at a discount.

For the latest and best art books I go directly to Amazon.com because I find their reviews and ratings invaluable. North Light Shop is another on-line company that specializes in the sales of: art books, instructional videos—searchable by art medium and instructor, DVDs, magazines, and much more. There is also a "Free Advice" tab on their site for great how-to articles.

One more free instructional resource is YouTube.com. Just type in the medium, such as acrylic, what you want to learn how to paint, such as clouds or a rainy sky, and up will pop a staggering amount of choices to explore. Some of these videos only last a few minutes, while others can go for over an hour. If you find an artist whose technique you like, you can visit their

website where they often have lessons for sale that can be downloaded or sent to you on a DVD. Tim Gagnon's website has great lessons you can buy or download while you're in the mood to paint.

So you have your supplies. Now what? Get your supplies organized and create a space where you can play with them—and really think of this as PLAY! Before you begin drawing or painting, spend a minute or two doodling anything on a piece of scrap paper. It can be as simple as drawing a bunch of large loops over and over again. You don't need to waste good drawing paper on this, you can use newspaper or paper bags. Why one or two minutes? Because that is usually all the time it takes to turn off the left brain, and turn on the right side.

Create a time out environment only for you. Since this is your time, you might want to:
- Pour yourself a glass of wine . . .
- Play your favorite music
- Turn off your phone
- Take off your watch and don't look at a clock
- Smile
- Totally enjoy the colors, the paper, and the process of being creative and playful

One more tip. If you plan to work in multiple mediums, and like to stay neat and organized, here is what works for me. I find that keeping smaller art supplies in attractive baskets works. Not only do they hid the clutter, it makes using various mediums outdoors, or in other areas of my house easy to find and transport. Here are two shots of my studio, formerly my garage.

I use two Husky 46 inch, 9-drawer mobile workbenches, with solid wood tops, and black drawers to keep all of my oils paints, acrylics and watercolors together (right-hand page bottom). I found them at Home Depot.

"Creativity is just connecting things.
When you ask creative people
how they did something, they
feel a little guilty because
they really didn't do it,
they just saw something
different. It seemed
obvious to them
after a while."

Steve Jobs

Enhance your creativity beyond art...

And get an **MBA** in **joy**
Meditation,
Breathing
Awareness

Meditation—slow down and get more done

Breathing—just be aware of what you are already doing

Awareness or Mindfulness—appreciate being in the moment

Playing with animals—with or without owning a pet

Exploring nature—with or without going outside

"When we rest the
mind in awareness, we
are also resting in creativity.
We are creating the conditions
to move effortlessly in life,
with a profound sense
of freedom."

HuffPost Healthy Living

Overview

What is meditation, breathing and awareness/mindfulness?

Meditation is an activity.
It is something that we do.

Many forms of meditation involve focusing on the breath using specific types or patterns of breathing that are easy to learn on YouTube.com or on the Internet. Meditation not only deepens our **connection to the NOW,** but by focusing on our breath, **it helps us reconnect, recenter, and come back to our awareness of who we truly are**—pure consciousness and pure love and light from the Universe.

In Matthew May's article, *Quick and Easy Ways to Quiet Your Mind*, which appeared in the December 24, 2012 issue of *Harvard Business Review*, he quotes lead researcher Eileen Luders, who explains,

"New research from the UCLA Laboratory of Neuro Imaging suggests that people who meditate show more gray matter in certain regions on the brain, show stronger connections between brain regions, and show less age-related brain atrophy. In other words, meditation might make your brain bigger, faster, and younger."

Eileen Luders

Breathing is what we do to stay alive. But did you know that we can use the breath in probably over one hundred ways to achieve different results— from calming the mind to achieving different states of consciousness?

Why is it important to focus on the breath? It is where the body, mind and spirit meet. The breath and the body are interconnected, therefore, when the breath is calm, the body is calm. Conversely, when the breath is agitated or labored, the body is agitated or labored. That is why when a person is in a state of distress, we generally tell him to take a deep breath and relax. Those two or three breaths help the **person calm down both emotionally and physically, and reconnect to Source.**

Awareness or mindfulness is a state of being. Jon Kabat Zinn, a scientist, writer, meditation teacher, and pioneer in the field of mindfulness, defines mindfulness as:

"Mindfulness is awareness that arises through paying attention, on purpose, in the present moment, non-judgmentally."

Jon Kabat Zinn

Many people think of meditation, breath work, and awareness as separate and distinct approaches for enhancing creativity. I believe the real magic happens when you think of each as a part of the whole.

By understanding that there is an interrelationship among these three practices, you will be less concerned about whether you are meditating, practicing awareness, or focusing on your breath. Think of them as one beautiful continuum, rather than labeling each element. Remember, you can't meditate or practice awareness if you don't breathe.

Awareness or mindfulness means you are an observer of your thoughts, emotions, events, and bodily sensations, but your state of being is not affected by them. You simply watch your thoughts, emotions, and events without reacting, judging, comparing, or labeling them. This state of being transports you to present moment awareness, or the NOW.

It really doesn't matter if you view each as a separate practice, or as a part of a whole. Each can help you:
- Enhance creativity
- Trust your intuition
- Appreciate life more fully

From this new perspective, you will see how meditation can help you to be more mindful and how mindfulness can be cultivated during meditation while "sitting on the mat," as well as in every moment of your life.

When you adopt an ever-present spirit of gratitude, practice conscious awareness, are mindful of your breath and meditate, real magic happens.

Why Meditation?

Today the value of meditation is no longer questioned.

Academic, scientific, and medical studies all agree and have been referenced in prestigious magazines such as *Scientific American, Harvard Business Review, Psychology Today, Mindful* and *Spirituality & Health*, as to the overall benefits and how meditation changes your body. For example:

• Your blood pressure drops
• Your brain releases "happy" chemicals that improve your mood
• Your digestive system runs more smoothly
• Your pain is reduced by 40%
• It can slow the progression of Alzheimer's
• It can cure tobacco cravings

Even if you only meditate for five to twenty minutes a day, you should see a wide range of benefits in just a few weeks.

Meditation will also help your creativity blossom.

Here are a few more benefits of meditating of which you might not be aware. As you read this list, check off those bullets that might improve your overall well-being.

Emotional well-being
- Lessens impulsivity
- Reduces worry, anxiety, fear, and loneliness
- Increases self-esteem, self-love, and optimism
- Helps develop positive social connections
- Improves emotional intelligence
- Makes you happier

Mental capabilities
- Improves focus and helps you to ignore distractions
- Enhances creativity
- Increases memory—both retention and recall
- Aids in better decision making and problem solving
- Helps minimize the impact of ADHD

Physical health
- Improves breathing and heart rate
- Reduces blood pressure
- Decreases absentee rate by improving the immune system
- Increases energy levels
- Lessens the impact of arthritis, PMS, menopause syndrome, and inflammatory disorders

I still hear you saying you don't have time to meditate. I get it. Here is a different mindset to try. Imagine not brushing your teeth for even one day. How would that make you feel? Probably like you were ignoring your well-being. Now think of meditation as an activity just as important as brushing your teeth. Once you see meditation as just as important, it may be easier to create the time to add it to your schedule.

Would you consider making the time to meditate if you knew that many of the most successful business people in the world attribute their success in part to meditation? (From *Meditation*, which appeared on onlineMBA.com—February 1, 2012.)

Why do these leaders of industry make time to meditate?
The reasons they give include phrases such as:
- It lowers stress levels.
- It delivers significant physical health benefits.
- It improves cognitive functioning, **creative thinking,** and productivity.

Need more proof? Here is just a small list of regular meditators, many of whom run **Fortune 500 companies:**
- **Rupert Murdoch**—Chairman & CEO, News Corp.
- **Padmasree Warrior**—CTO, Cisco Systems
- **Tony Schwartz**—Founder & CEO, The Energy Project
- **Bill Ford**—Executive Chairman, Ford Motor Company
- **Oprah Winfrey**—Chairwoman & CEO, Harpo Productions, Inc.

- **Larry Brilliant**—CEO, Skoll Global Threats Fund
- **Ray Dalio**—Founder & Co-CIO, Bridgewater Associates USA
- **Russell Simmons**—Co-Founder, Def-Jam Records and Founder of Global Grind
- **Robert Stiller**—CEO, Green Mountain Coffee Roasters Inc.
- **Arianna Huffington**—President & Editor-in-Chief, Huffington Post Media

The list above appeared multiple times in HuffPost's *The Third Metric*, in an article entitled *The Daily Habit of These Outrageously Successful People* by Carolyn Gregoire. Here are a few quotes from several of these meditators:

- "Meditation, more than anything in my life, was the biggest ingredient of whatever success I've had." Ray Dalio

- Padmasree Warrior told the New York Times in 2012 that taking time to meditate and unplug helped her to manage it all. "It's almost like a reboot for your brain and your soul," she said. **"It makes me so much calmer when I'm responding to emails later."** I think we all can relate to that.

- Arianna Huffington has spoken out on the benefits of mindfulness, not just for individual health, but also for corporation bottom lines. "Stress reduction and mindfulness don't just make us happier and healthier, they're a proven competitive advantage for any business that wants one," she wrote in a recent blog.

Other reasons to consider meditating are:
- It leads to neuroplasticity of the brain—the ability for the brain to grow and change by building more neuron connections—which actually improves how the brain processes information.
- It increases gray matter, which helps slow the aging process and aids in decision making, focus and memory.

- It can give you a second wind, which may be more effective than taking a nap.
- It can be more effective in controlling pain than morphine.

Still not convinced it will help you in business? Guess what? Many of the most successful companies encourage the practice and provide classes to teach employees how to meditate. Here are just a few highly successful companies that appreciate the ROI (return on investment) of having their employees meditate. This list appeared in the article, *10 Big Companies That Promote Employee.*

Apple

Apple
Steve Jobs promoted meditation at Apple, and some believe that his meditation practice was instrumental in his creativity and ability to develop products we didn't know we couldn't live without.

Prentice Hall

Prentice Hall Publishing
This company has meditation rooms where their employees can take a break, refocus, and reduce stress.

Google

Google
Google offers their employees meditation classes, which they believe can improve employee health and well-being while being good for the company's bottom line. Google also offers a class called "Search Inside Yourself," which teaches people how to breathe mindfully, improve their emotional intelligence, and work better with their coworkers. Chade-Meng Tan introduced this course in 2007 and more than 500 employees have taken the class—so it must be working.

Nike

Nike
Nike has relaxation rooms where employees can meditate, pray, take a nap, or just chill.

Aol

AOL Time Warner
AOL is another of many smart, forward-looking companies. It introduced meditation classes in 2000 as a way to help employees deal with the stress resulting from dramatically downsizing the sales and marketing staff without reducing the demands on the staff that remained.

Deutsche Bank

Deutsche Bank
This conservative global banking and financial services firm began offering meditation classes as a means of reducing stress during the highly turbulent times of the global economic crisis and promoting levelheaded thinking.

HBO
HBO provides employees with yoga and meditation classes to help promote creativity.

McKinsey & Company

McKinsey & Company
A leading management and consulting firm promotes meditation to help keep employees healthy and happy.

Procter & Gamble
Their CEO, A.G. Lafley, is a regular meditator who wants his employees to have access to meditation training along with other programs that promote health and wellness.

Looking at meditation from another perspective. In today's fast-paced society, we rarely stop to think about how we can enhance our own creativity. Constant multitasking, along with reliance on multiple devices, enslaves us, making us more reactive than proactive than ever before. It is no wonder that we can't concentrate on one thought or problem at a time—there is always another email or call demanding our attention.

Taking time to meditate is like hitting "the time out for me" button, to stop thinking, to just be, to experience an inner level of calm, to gain new insights, and to finally relax. It's easier once we stop feeling guilty about taking the time—and it's one of the smartest ways to access our creativity.

In her article *Manners for Your Mind* which appeared in the August/September 2016 issue of *HiLuxury*, Christina O'Connor writes about the benefits of meditating for a longer period of time in order to gain new insights. One of her meditation teachers, Hamai, at Bodhi Tree, remarked,

"Basically, you are left alone with your mind for about an hour or so, and in that time, you start to see how your mind works."

Hamai

"The creativity that we're looking for is already there . . . we just need to learn how to sit back and allow it to appear. The more often we do that, the more familiar it becomes. In this way, it would be quite right to talk about meditation, in a creative context, in terms of 'the discovery and familiarity' of creativity."

Hamai
HuffPost Healthy Living

Continuing to quote her teacher, Hamai, Christina O'Connor said, "You're able to find more different, creative solutions because you are not stuck in one mindset. If your mind is more relaxed and more open, various different solutions come up and you can handle things in a different way."

Various studies worldwide have shown that meditation can improve creativity and creative thinking. Meditation can have a long-lasting effect on cognition even after we have stopped meditating on a regular basis.

"Neuroscience tells us that to be more productive and creative, we need to give our brains a break. It's the quiet mind that produces the best insights," says Matthew May in his article, *Quick and Easy Ways to Quiet You Mind,* which appeared in the *Harvard Business Review,* December 24, 2012.

Taming and appreciating your mind. To optimize your experiences with meditation, here are a few tips to keep in mind:

1 Let go of expectations. When you decide to begin meditating, it is best to just begin without expectations. Each time you meditate, you will most likely have a different experience. This is true even for many longtime meditators. Just remember that each experience is perfect for that moment in time.

2 A meditation session may leave you feeling like you have accessed a perfect sense of stillness, while other times you may feel annoyed, restless or plagued with unwanted thoughts. Just let your experience be. Be the observer without judging,

labeling, or comparing. There is no correct way to meditate and no wrong way to meditate. Relax and trust your inner knowing or higher self to guide you into the stillness that is always there.

3 Let go of limiting beliefs. Here are some common beliefs that you may use to justify not meditating:

- It's a waste of time. I should be using that time to get something more important accomplished.
- I am sure I would do it wrong.
- I could never sit still for that long.
- My house is always too noisy.
- Meditation is only for old hippies or rich people.
- I think it is really boring.
- Meditation classes are expensive.
- Meditation is like joining a cult.
- I'll never stick with it, so why bother starting?
- What would other people think?

According to renowned author Deepak Chopra, meditation can awaken your mind's inner intelligence and creativity. "It is not about forcing the mind to be quiet, it's finding the silence that's already there and making it a part of your life."

4 Need more serious proof? Then listen to John Hagelin's presentation on meditation on YouTube.com. Not only is he a Transcendental Meditation (TM) instructor, he is also a highly acclaimed quantum physicist.

5 Investigate hi-tech ways to enhance your meditation. Special music and sound recordings, based on using different frequency levels in combination with the latest sound wave technology, are available for free on YouTube. This type of sound is called binaural beats. Just search the words "meditation music binaural beat." The one thing to know is that you need to listen to the sound using headphones.

Just ask an expert. When Ken Wilber, America's most cited living philosopher, was asked what the average person could do **to raise their consciousness,** his reply was, **"There is already a technology that can be used to raise human consciousness. It's called binaural beats."**

You can try my favorite binaural music for free on-line. It's a program called OmHarmonics from Mindvalley. OmHarmonics' sound programs not only use binaural beats, they use other frequencies to enhance your meditation practice. Their site is OmHarmonics.com.

Here is how it works, as explained on the OmHarmonics website. "Binaural beats play one frequency in your left ear and a slightly modified frequency in your right ear. This causes your brain to effortlessly create a third frequency, which exists entirely in your head. This third frequency can be used to create altered states of consciousness to help you relax, focus, sleep better, and more."

The beauty of OmHarmonics is that there are six different sound tracks you can use throughout your day. Here is more information about three of the tracks:

> **The Start of the Day**—when waking up
> **The Focus**—to enhance productivity at work
> **The Spark**—for turning on your creativity

To learn more about the benefits of all six sound tracks, go to OmHarmonics. com. If you are interested in learning more about The Spark sound track, which turns on your creativity, here is what they say on their website:

The Spark
Time of Day. Reignite your passion and fuel your creativity during a brainstorming session, when you need to come up with new ideas or whenever you are faced with a challenge in life.

How it Works. It expands your mind and helps you generate ideas without restriction, harness solutions without being attached to the problem and opens the gateway to answering any questions.

The Benefits. Increased creativity and innovation, an enhanced ability to absorb information, an open mind and better judgment.

Become Inspired in Just 15 Minutes with The Spark and enjoy your creativity flow.

All sound tracks come in both a thirty minute and fifteen minute track. The other three tracks are: **The Balance, The Deep Rest and The Six- Phase Meditation**. Can you visualize the kind of impact this would have on your life? Using OmHarmonics you can experience:

Less stress. Studies show that binaural beats relax your muscles and declutter your mind. **Better sleep.** With OmHarmonics you will experience more refreshing, rejuvenating deep sleep.

Increased creativity. Amplify your ability to tap into ideas and create new ones. By connecting thoughts from both your conscious and subconscious mind, OmHarmonics will help you unlock new ideas easier than ever before.

Sharper focus. Effortlessly achieve laser-sharp focus and develop a goal-oriented mindset. In this state of mind, you can accomplish all your daily tasks in less time.

This section is taken directly from the OMHarmonics' website.

There are other resources you can investigate on Amazon.com. For example, while the title is, *Shumann Resonance Inner Depths*, you get to it by typing in, *Probably the Best Music for Relaxation and Meditation*, which is a smart name from a marketing perspective! They have two sound tracks

you can download to your smartphone for $.99 each. You can listen to a sampling of each sound track before buying. To learn more about their technology, read the reviews.

Source Vibrations produces tuning forks and binaural beat CDs that you can sample at: sourcevibrations.com. Here is what they say on their website: "Source Vibrations music uses leading edge vibro-acoustic tools for consciousness evolution. We employ sacred geometric sound design, integrating golden mean mathematics, universal harmonics, sacred tunings like 432 Hz, and Solfeggio frequencies for establishing resonant fields of internal coherence. Our music uses an emerging Golden Age synthesis technology, converging the code of the cosmos within the structural design of engineered sound. Embedded with mathematically tuned brainwave entrainment technology, our music promotes hemisphere synchronization, cognitive and bio-energetic evolution, sonically entraining the structures of consciousness into the transcendent frequencies of the Source."

"In listening regularly, you are activating dormant internal resources that can enhance your clarity, balance, and well-being. Vibrating through interior conduits, these sound sanctuaries act as a gentle solvent, loosening and removing the energetic debris of past memories and emotions, clearing the channels for more abundant life-essence to flow through you."

Lynne's fun guide to meditation

Find a quiet, dimly lit space where you won't be interrupted. Make sure phones are off and that there are no TVs or noisy appliances running.

Be comfortable and wear loose-fitting garments. Remove your shoes. If you are dressed for work, consider removing, loosening your belt, tie, and take off your Spanx— if you are wearing them.

It's always great to light candles and burn incense before you begin meditating. Not only is it calming, it helps create a sacred space that is conducive to meditating. Meditating in the same spot is aways good.

Sit with your spine straight but don't make it stiff. It doesn't matter if you sit on the floor or on a chair. Remember that meditating is a great way to enhance your creativity, intuition, and to be more receptive to innovative ideas.

Sitting on the floor. There are several ways to sit on the floor. You can sit with your legs crossed and your hands gently placed in your lap, palms facing upward, left hand cradling the right. Or you can sit on the floor with your back up against a wall, with one or both legs outstretched.

There are also several great types of seats you may want to experiment with that can make it easier and more comfortable for meditation. You can use:

- A rolled-up towel under your backside
- A wooden meditation bench or a special meditation seat
- A meditation cushion, such as a Zafu (shown on the facing page)

Here is a Zafu cushion which is comfortable.

My favorite meditation seat is made by Salubrion.® There are several advantages to the Salubrion seat—unlike a Zafu, it doesn't lose its shape over time. It is also smaller, lighter, and more portable. You can order one at Salubrion.com.

Sitting in a chair. You don't have to sit in a cross-legged position on the floor to meditate. You can just as easily sit in a straight back chair. Keep both feet on the ground and don't cross your legs or ankles.

Here is how to begin meditating. Close your eyes and relax. Take slow, deep breaths through your nose and exhale through your mouth. Position your tongue on the roof of your mouth about one inch from your front teeth. Take four or five deep relaxing breaths, making sure that on the inhale your belly expands, and on the exhale it contracts. This kind of deep, mindful breathing can help settle the mind and calm you down, then settle into a more natural breathing pattern. You can continue meditating by focusing on your breath or by using a mantra such as OM or AUM.

After a few minutes pass, you no longer need to consciously focus on your breath or on your mantra. Your awareness simply falls away as you become more centered and your mind is still.

Now, just as you are unconsciously enjoying that quiet stillness, a THOUGHT may pop into your brain that pulls you back into the "reality" of everyday life. How very rude of that thought. The audacity!

Often, this one simple thought is all your mind needs to invite even more distracting thoughts to follow, which makes matters even worse. For example, here is one simple thought: "Oh, I have to remember to pick up my dry cleaning tonight before the place closes."

This initial thought may be followed by: "I wonder if they've changed their hours? What were those hours, anyway? Oh, I'll just Google them to be on the safe side. Oh, it'll be okay if I forget; I can always wear a different outfit. Which reminds me—I have to remember to order theatre tickets before that date is sold out."

After this series of thoughts, you may decide that this is the perfect time to stop meditating—justifying this decision by telling yourself that you are one of those people who just can't meditate—which we know isn't true, it's just a limiting belief. But here is the inside scoop. When your mind presents a pressing thought to interrupt your bliss, you have a few options.

You can get annoyed.

You can simply observe your thought, ignore it, and see it fade away. Just remind yourself that you can deal with the issue or task when you're finished meditating. Even if a thought is negative,or causes negative emotions to comes up—whether it is fear, anger, jealousy, or hate— just notice it and release it. It will quickly dissipate.

Or, you can get up and go to the dry cleaners!

While many people think it is a bad thing when a thought pops into your head that is not the truth.

My chart explains why I see thoughts as a good thing.

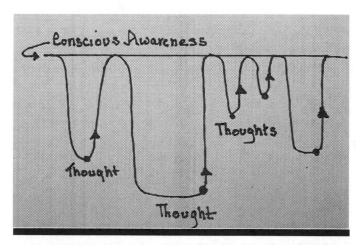

The straight horizontal line represents your awakening state of consciousness. The downward curves represent your mind getting quieter and quieter as you go deeper into your meditation. The bottom of the curve represents just how long you stay in that deep state of consciousness.

Then all of a sudden a thought enters your mind and you bounce back up to an awakened level of consciousness. Then you put that thought aside and you begin quieting the mind once again by conscious breathing, or repeating your mantra.

This pattern can occur multiple times during a meditation. Instead of getting upset, realize that this is a perfectly normal occurrence and really a good thing. What I was told by a Transcendental Meditation (TM) teacher years ago ,was all this means is that the energy that moves through your body hit a pocket of blocked energy. The purpose of the up and down movement caused by your thoughts helps dissolve and release the block. When you think of it that way, these up and down movements are instantly less annoying. Now whether this is true or not, it doesn't really matter. What matters is that it is an empowering way of interpreting what is occurring.

For fun, I always set the stopwatch feature in my iPhone when meditating. This way I can see how long I meditated. This approach is worth trying. It can be really surprising to think that you only meditated for five or ten minutes, when the actual time was thirty-three minutes. Do not be concerned if you happen to fall asleep when meditating. All that means is that you needed the sleep—no worries. What I would advise, is if you have to be somewhere by a certain time, set the alarm on your phone to ensure that if you do fall asleep it doesn't cause you to miss an appointment.

A few more helpful insights

Be aware that we are not our emotions—including the ones that come up during meditation. Remember, when strong negative emotions arise, it is generally because we may have created an "exaggerated and dramatic story" around an event, or situation based solely on our interpretation of what happened or didn't happen.

Why do so many people seem to enjoy focusing on negative people and events from the past? You know the ones. They are the people who enjoy holding grudges, are constantly complaining, are plagued with mind chatter—rehashing the past, regretting what they said, or what someone else said. Want to know what the real underlying motives are behind these actions? **It's because this perspective lets the person play the victim.** Now they can proudly tell their tale of woe to anyone and everyone who will listen, which is really their strategy to be the center of attention.

This pattern of victimhood can also stem from insecurity and a need to be right. Do you find yourself plagued by negative self-talk about yourself, others, or events? Here is what you do—**you just stop it!**

Instead of reacting negatively to these events, which will only harm you, try to take the higher road by forgiving yourself for initially wanting to

retaliate, forgive the other person, and send thoughts of loving-kindness to everyone involved.

The good news is that once you do that, you can move on. It will make you will feel much better, and will probably annoy the person who was the source of your anger. So try it and see how the person reacts.

Here is a story I created thirty years ago around a dating situation. I had a first great date with a man I met at an art event. He was elegant, very smart, worldly, etc. We went to dinner, had a great time, and discovered that we had much in common. **But when I didn't hear from him after seven days passed, I was more than slightly disappointed**. So naturally, I shared my angst with a friend who happened to be a therapist. The first thing she asked me was, "What do you think happened?"

Well, that was all I needed to rattle off a whole bunch of different, **but quite creative, scenarios of what I imagined I had done wrong, or hadn't done, etc.** After all, I did have seven days and nights to be annoyed that he hadn't called, and to imagine a great variety of scenarios.

After listening to three or four of my most dramatic stories, my friend just smiled and laughed. With much chagrin at her flip attitude, I made a sad/angry face—to which she replied, "That was interesting, but the only thing you know for sure is that he didn't call you—end of story. Drop the drama, release it and relax. If he is meant to call, he will. If you want to call him and if that feels right, then call him. It is really that simple." So much for my dramatic stories.

My friend practices a type of therapy called Cognitive Behavioral Therapy. After she took the time to explain the theory behind the approach, I was impressed with how it works and the methodology on which it is based. An abbreviated version of the Cognitive Behavioral Theory is: When people are involved in a stressful situation, their minds rationalize their discomfort by

making up self-defeating stories that reinforce their underlying beliefs, such as, I'm not enough, I am unlovable, I will never be successful, etc.

More on the Cognitive Behavioral Theory. If this method sounds intriguing, read Dr. David D. Burns' book, *Feeling Good—The New Mood Therapy,* where he details dysfunctional ways people tend to view situations, such as:

• "All or nothing" thinking
• Over-generalizing
• Disqualifying the positive
• Jumping to conclusions
• "Should" statements
• Awfulizing—magnification
• Emotional reasoning
• Labeling and mislabeling

Understanding more about these common patterns of thinking helps individuals reduce their tendency to over dramatize the events in their lives, while reducing stress and helping them live in the now.

Back to Meditation. Studies show that meditating for twenty minutes a day provides more psychological rest than a full night's sleep. People who meditate regularly need less sleep and have more energy. So the next time you think you can't make time to meditate, consider trying meditation as a strategy to gain more time and energy than the time you spend meditating.

You will have more focus and patience. As you pay attention to your breathing during meditation, you improve your ability to concentrate and focus for longer periods of time. One thing that both beginners and long time practitioners of meditation have in common is that they sometimes experience a sense of boredom. Really. But once meditators get past their initial inclination to cut their meditation short and get onto their "pressing issues of life," a new level of patience evolves naturally.

You will have more calmness and clarity. Once you begin meditating, you will be surprised at just how quickly you start to experience and look forward to the sense of calmness it instills. From this space of calmness, a new level of clarity can become ever-present. This state of being makes your mind sharper, and lets you access deeper levels of creative thinking and problem solving.

I encourage you to explore various meditation styles, and to listen to binaural music on OmHarmonics.com or YouTube.com. Just remember to use headphones when using binaural technology.

Breathing
All you have to do is be aware of what you are already doing

What comes to mind when you think of the word *breathing*?

Sure, it's an essential activity for staying alive. By being aware of your breathing, you will know immediately if you're frightened, overexerting yourself, having a panic attack, are relaxed, or calm. According to various yoga masters, there are over one hundred types and patterns of breathing.

Some breathing patterns are designed to: energize you, access a deep stillness within, help you recuperate after an illness, access past life memories, improve physical endurance, or accelerate mental, emotional, and spiritual healing, just to name a few.

Begin by trying various breathing techniques, get a baseline of how you typically breathe. Do you take long, slow, deep breaths that make your belly inflate, or do you take short, shallow breaths from the upper part of your lungs where your belly doesn't move at all? If you are not sure how deeply you are breathing, try lying on your back and place your hands on your belly. As you breathe, notice if your belly inflates. Below is a visual to help you think of your breathing pattern based on a circle.

Experimenting with the basics. On your inhale, take a slow deep breath for the count of four and let your belly fill up with air. Now before you exhale, hold your breath for a count of four. Slowly exhale for a count of four and bring your belly back toward your spine to force out the air. Before you inhale again, pause your breath for a count of four. This pattern of breathing may initially feel strange, but over time it will feel natural.

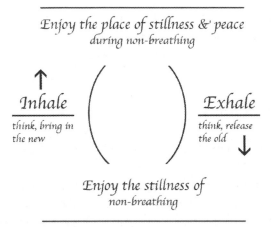

Enjoy the place of stillness & peace
during non-breathing

↑
Inhale
think, bring in
the new

Exhale
think, release
the old ↓

Enjoy the stillness of
non-breathing

During the day, notice what type of breathing pattern you are using as you do various activities. Has anything changed? Before you fall asleep, take a minute to focus on your breathing. Lightly place both hands on your belly and notice if it rises up as you inhale and deflates as you exhale. If it doesn't, take a few long, deep breaths, making your belly inflate.

This type of breathing helps calm your nervous system and deliver more oxygen to your cells. It helps you sleep more deeply giving your body time to heal, relax and revitalize your energy.

How to best observe the breath

Slow down, relax, drop your shoulders, and smile. Now close your eyes and follow your breath. This is one of the easiest approaches to meditating.

Just follow the inhale and exhale and observe the top of the breath and the bottom of the breath—the places where you can access stillness and peace.

Why the smile? Did you know that faking a big smile—where the area around your eyes crinkles up—reduces stress, improves your mood, produces a change in brain activity, and is good for your overall health? It is true. So smile, especially when you are not really feeling all that good—trust me, it will make your brain happy!

Roger Dooley, the founder of Dooley Direct, stated in the opinion section of Forbes entitled, *Why Faking a Smile is a Good Thing*, "We think of our face as reflecting our internal emotions, but that linkage works both ways. We can change our emotional state by altering our facial expression! Pasting a smile on your face, even if you are consciously faking it, can improve your mood and reduce stress".

Awareness or Mindfulness
How to appreciate being in the moment

Awareness is nothing more than
being fully present, simply
observing what is happening
in the present moment
without judging, comparing or
labeling . . . and without
having any thoughts.

A guru I once studied with taught that we automatically feel the need to label everything we observe. Think about that. Does that ring true for you? **Labeling is a thought that actually prevents us from being fully engaged in the moment** That is because our mind likes to be in control, and even one tiny thought leads to another and yet another.

Fortunately, over time you can become a detached observer of what is happening without judging, labeling or comparing. Awareness is having the power of pure observation.

What is awareness or mindfulness?

To begin with, mindfulness is a decision—one that you reaffirm throughout your day—and it is also an intention that you set. What does this mean?

It is pausing to be present, or in the now.

In today's frenetic world, many times we are either living in the past or

worrying about the future. The problem with this is that the magic in life is only here in the present moment.

It is a state of being

Jon Kabat Zinn's definition of mindfulness is "paying attention on purpose, in the present moment and non-judgmentally, to the unfolding of experience moment to moment." Jon Kabat Zinn is a

scientist, writer, and meditation teacher who has brought the practice of mindfulness into medicine and the mainstream.

Meditation, breathing and awareness/mindfulness are the three elements that help you appreciate life more fully, be in the moment, and stop the constant mind chatter or self-talk.

While many people think of meditation, awareness, and breathing as different and distinct approaches for reducing stress and enhancing creativity, I believe the real magic happens when you think of each as one element of the whole. I believe that gratitude is also an integral part of the whole, which add the magic.

Are you constantly plagued by your thoughts or mind chatter? You know, that little voice in your head that is always making you wrong? Well these thoughts can make you miserable and prevent you from being fully present in the moment.

Meditation works wonders for stilling your mind chatter. Here is another technique for quieting this critical voice. It's easy. For example, I may look outside and see a tree that I have watched grow over the last twenty-four years. I observe how beautiful he is and tell him how handsome he is, how strong his branches look, how much the birds like to hang out with him. I could go on, but the key is to pay attention to something that you normally don't notice and then to send loving appreciation to the tree. This simple will change your relationship to the tree and to yourself. This form of gratitude stops that negative voice in your head almost immediately.

Think of gratitude as the magic sauce of life. By understanding the interrelationship of the three practices, you will become less concerned if you are meditating, practicing awareness, or focusing on your breath. I think of this combination as one beautiful continuum, rather than being concerned about labeling things.

Here is my day . . .
when I slow down and practice mindfulness

When I wake up (a slow process), first I snuggle with my bedtime partner, Little Girl, a seventeen-year-old tortoiseshell cat. She helps wake me up with a gentle paw patting on my cheek repeatedly, urging me to wake

Meet Little Girl who is now one of my guardian angels

up and give her attention. When I don't wake up on her schedule, which generally revolves around eating, her claws come out just slightly to ensure I wake up.

Then I observe how I feel, give thanks for the day, for the trees I see from my window, and for the weather. It doesn't make a difference if it is sunny, cloudy, raining, or snowing, I see the beauty in the uniqueness of all types of weather. I am always sad when people let rain, snow, heat, or humidity determine how they feel. For example, have you ever heard, or do you hear yourself saying, "What a terrible day. I can't stand this rain?"
Why give away your power of how you feel based on certain types of weather? Rather give thanks for being alive, and send loving energy to those places on the globe that would so appreciate the rain, snow, and hail.
Next I review my priorities and appointments for the day—or not, knowing that what is meant to occur will.

My top priorities do not always get done. For example: Recently I began talking to a British man I met while waiting impatiently for the very late, two-car train that transports people from the Princeton Junction to Princeton Station—a three-minute ride. When we realized that the train was running more than ten minutes late, we considering sharing a cab to the station. When we discovered that the cab charged $20.00 for the three-minute ride, we decided to pass the time in conversation and practice being content and in the moment. Finally, the train arrived and transported us to Princeton where my car was parked.

By this time, I had learned that he was here on a five-month fellowship at Princeton University, living in a furnished house, a distance to transportation, didn't have a car and didn't know his way around. I was surprised that no one at Princeton had given him a tour of the area.

Not only was he here without a car, he didn't know that my three favorite supermarkets—Wegmans, Whole Foods, and Trader Joe's— existed, even though he had been in town for five weeks! Can you imagine? **Not knowing if you could find Marmite, Bird's Pudding, or Mrs. Ball's Chutney in Princeton? Such rude Americans! Since I had planned to run into all three stores** right after I dropped him off, I decided it was my job to introduce him to Route 1 and to take him into each market so he could finally buy some real food.

So maybe I didn't do any writing that evening as planned. It was a fabulous day being helpful to a once-stranger. You see, I know what it is like being in a foreign country and not knowing anything. I was always very appreciative of the people I met who took me under their wing and made sure I didn't miss anything important. That's because at one time in my life I spent three months a year in Europe. After I finished grad school, I began working for Polaroid as their International Manager for Business, Professional, and Medical Products along with the product line of peel-apart film. Remember those days when photos had to be unpeeled to be seen?

Thanks to my meditation and mindfulness practices, I have come to expect the unexpected and to know that everything gets done at the perfect time. I also had a chance to help another person get acclimated to Princeton. Not only did I begin taking him to the grocery stores weekly, I pointed out all the stores his wife should go to when she came for a visit. I am sure he really appreciated the latter . . . or not!

Now back to how I "do" a day of mindfulness.

Next I set the intention for the day.
I declare that it will be joyous, happy and full of adventure—
whatever that means—probably something similar to
the event I just shared.

Some days this can be nothing more than trying
a new food sample at Sam's Club or Costco,
which then becomes my favorite food
for the next two months.

No matter what unfolds, I see myself being
in the now and in the flow and getting my work done
and in perfect timing. My mantra is,
**"I am a clear and open channel for
the love and light of the Universe."**
Feel free to use my mantra, because that one phrase
helps me relax and adjust my attitude when doing the mundane
from one of annoyance to one of appreciation.

This generally works for me, unless I am being too self-absorbed
to get into that head space of surrender. **I remind myself to
slow down, be mindful, and come from a sense of
gratitude for all things, especially when I would
prefer to rush through certain tasks**—such as making

the bed, cleaning out the coffee machine, changing two kitty litter boxes, and cleaning up after myself—before I start my day.

Now instead of seeing the chore of emptying the dishwasher as a source of annoyance, I re frame the time I spend completing the task in a more positive manner— at least when I am conscious enough to be mindful. Here is what I do.

I really slow down and observe how I empty the dishwasher. I tighten my stomach muscles and recognize that I am actually exercising.

I also use this time to send love to all of the people and materials that it took to produce each plate, bowl, and knife.

As I put each item away, I switch into a sense of appreciation for having pretty pale yellow dishes, and I remember how elegant food looks on the plates.

After the job is done, I look at the clock and realize that the entire job of "emptying the dishwasher" took me less than two minutes. So by slowing down and observing each element of the process, this otherwise annoying task is instantly transformed into an exercise in mindfulness and gratitude.

So you see how easy it is to incorporate mindfulness into every moment. This tiny shift in attitude and perception makes all the difference in the world, and helps set the tone for the day. **You can think of mindfulness as paying**

attention to your experiences as they occur without judgment, labeling, comparing, or adding a running commentary or drama to each simple event. **As you begin practicing meditation and mindfulness,** you will find

yourself being in the present moment more often until it becomes a natural state of consciousness. You will also become more compassionate toward others as well as toward yourself. You may even become wiser, more patient, forgiving, loving, and content with your life.

As we shift our awareness of how we create, and experience reality, we begin to see others differently—as stuck in an old paradigm where they choose to live their life as a victim. From this perspective we can be more compassionate, especially when we interact with people who are either living in the past or worrying about the future.

Every time you are not in the present moment, you may be coming from a place of fear rather than unconditional love, joy, and trust.

Being in the moment. Take a minute to reflect on your typical day—if there is such a thing. **How much time do you spend thinking about the past or worrying about the future?** When you are doing chores, you may find yourself focusing on regrets and annoyances from the past or honing in on concerns about the future—anything to avoid present-moment awareness. When you shift into present-moment awareness, you create a space for appreciation and gratitude and can access your ever-present inner wisdom.

When we forget to be in the present, we are not really engaging in life. Want more presents in your life? Then remember to be present more often.

The more time we spend meditating and being mindful, the easier it is to let go of the need to control and to accept reality as it is—without judgment, labeling, comparing, drama, or fear. Access the perfection in every moment, even the ones that push our buttons the most.

Playing with animals
without even owning a pet

**Playing with animals can help put you in a good
mood which enhances your creativity**

Take a second and just think about it. If you currently own a pet, you probably already agree with this statement without knowing how, or why playing with a pet enhances your creativity.

Just being in the presence of animals can transport you to present-moment awareness. It doesn't matter if you stop to feed your pets two hours before their usual dinnertime, because they are giving you that look that screams, "But Mom, we are hungry now!" or, if you are just watching their them sleep.

Even when you don't have time to play with your pets, looking around your

house to see what objects you can find to give them to play with engages your imagination. Try to look at ordinary objects from a new perspective. This duster that was a perfect toy for Bear to play with—he is one of the three Manx cats we currently have.

Being with animals can make your heart smile, and connect with a genuine feeling of love for them. This attitude helps you come from a higher vibration—where creativity happens more readily. If you don't

have a pet, playing or talking to a neighbor's pet can help you to be in the moment and feel a sense of awe for the animal's unconditional love for being alive and for his owner.

Giving presents to animals and children that aren't yours, and for no reason makes me happy. I always keep new dog toys and treats, new stuffed animals for children in the trunk of my car to give. I always introduce myself to the parent first, and quietly ask if their dog or child would like a present before I bring out any treats or toys.

Here are my two new friends, Hank on the left and Plato on the right. The owners are training Plato to be a seeing-eye dog. So naturally they both deserve several treats. They are both beyond cute, and very happy.

Ask yourself these questions:
Do you play the same games, or do you make up new games and buy them different toys from time to time? New games and toys help keep both dogs and cats happy and let you exercise your own creativity.

For cats:
Do you dangle fishing-pole-type toys in front of your cats in a manner that stimulates the behavior of prey in the wild? That is also important. Think about it. The prey may move quickly for a second or two, then stop and hide. Always let the cat catch the toy.

One of the best (and least expensive) games I ever "invented" for my cats is what I call, "The Feline Edition of the *Wall Street Journal*—The Game Designed for Highly Intelligent Hoinash Cats!" Buy a thin wooden dowel, about three feet long by 3/8" in diameter, at a craft store or at Home Depot—it generally costs less than a dollar. Next find a newspaper and spread the pages out all over the floor. The more paper the better. Next put the dowel under the newspaper with just a tiny piece of the dowel showing. Then as soon as the cat notices it,and is ready to attack, pull the dowel back under the newspaper. Repeat this over and over again, just let the dowel peak out from various locations.

No matter where the cats are in my house, at the very first sound of newspaper being crumpled up, all cats appear ready to play. The more cats you have the more dowels you will want. In the photo above the dowel is slightly to the right of the furry toy, which also works. You can use this same technique under the corner of an area rug or a towel. Try it. It is great fun. It gives your cats an opportunity to stalk, chase, pounce, capture, and show off in front of you.

By giving yourself permission to get down on the floor and play, you open up the floodgates to your creativity.

Remember that anytime a box comes into your home, you know just how quickly the cats will jump in and claim it. If the box is big enough, take a few minutes to tape it shut and cut a few holes in two facing sides of the box but in different positions, making the openings just big enough for the cats to get into the box, but not too big to eliminate the challenge. Let this orientation be the game for a while.

Now rotate the box ninety degrees so one of the sides with a hole is flat on the floor, leaving the other side with a hole facing the ceiling. Once the cat is in the box, dangle a toy just above the opening so he/she has to jump up to try to capture it. Let the cat catch the prey and drag it into the box. Make the game easy enough to be fun while still challenging.

Want another variety? Return the box to the original position with both of the "hole" sides exposed. Now cut a long narrow opening on the top, through which you can insert a stick—the kind with feathers at the end. What you will notice over time is that each unique game you make up for your cat is an opportunity to be creative while simultaneously having fun.

Make a real mess. With the cats watching, hide 98% of the dowel under the newspaper, leaving the end of the dowel peeking out. You can see just the smallest amount of the dowel peaking out to the right of the green toy. These games, while they may seem silly, really help to bring back the playful child in you, as well as helping you to be in the moment, smile and know that you are creating the groundwork to be more creative in all aspects of your life.

Make the movements quiet or noisy and try lifting the dowel a few inches from the floor while still under the papers. You'll have to try this activity to really appreciate how entertaining it is for everyone—humans included. The more creative you become (or realize that you are), the more fun you will have making up ways to play with your cats or dogs.

Another game my cats are wild about (that I'm hesitant to share) is called, "Let's Destroy the Perfectly Placed and Patted Pillows Mom Just Did—Because We Love Her So Much." **Here is how it works,** if you haven't guessed already. If you are a woman reader, you understand that there are never enough pillows on a bed—especially the decorative type that many men don't get, **but that cats totally appreciate.** Their motto, I am sure, is, "The more pillows and the more of a mess, the better."

After the bed is perfectly made, take their favorite wand, dowel, or fishing-pole type toy and put it behind one row of the pillows. Quickly show it to them and then make it disappear. They will pounce, destroy the symmetry of the pillows, and have fun. Let them enjoy their victory when they catch the toy.

Exploring nature
with or without going outside

We all appreciate nature. But most of the time, we take our immediate surroundings for granted. Often, it is only when we take a vacation that we stop to really notice the beauty of Mother Earth—often placing the lens of a camera between our direct experience of Her, as if we will make the time to truly soak in the majesty of the place once we are back home and the photos are revisited or printed—which we all know rarely happens.

Being in nature for even just a few minutes can enhance our creativity. Try any of these exercises:

Go outside day or night and say hello—in your mind or aloud—to Mother Earth and Father Sky. Slowly breathe in the smell of the air. Notice what that experience feels like. Thank Mother Earth and Father Sky for all of the magic and wonder they provide. Smile. Return to reality—noting that you are probably now connecting with a heartfelt sense of gratitude.

Go outside barefoot, even if there is snow on the ground, it is raining, or the sand is hot. Wiggle your toes. Stand still for just a few seconds. Imagine the following happening: feel Father Sky sending you magic streams of beautiful glittery energy. You can feel this energy and light, but not see it because it is vibrating at a frequency your eyes can't detect.

Know that each cell in your body depends on energy to be healthy, alive, and that same energy is there for us all of the time.

Now sense if there is any disharmony in your body, without stopping to give it a name. When you sense pain or discomfort, simply ask your body why that body part is hurting and if there is a message your body is trying to communicate. If you get an answer, ask your body what can you do to address the issue. Then follow those insights, and see your doctor as well.

To feel better, try feeling relaxed. Now feel as though your cells are absorbing the energy from Father Sky, while Mother Earth uses her

gravitational pull to drain any physical, emotional, mental, or spiritual disharmony from your body to make room for the love and light of the Universe. It's worth a try.

To make the exercise above even more powerful, find a tree to hug while you do the same exercise. Does that feel any different? If so, be with exploring the difference using all of your senses.

Buy fresh flowers, and honor the beauty and perfection of how they look and smell and how they make you feel—gratitude, in the moment, happy to be able to have flowers in your life whenever you choose.

Arrange the flowers in a different manner than you would usually do. For example, I just recently picked up what I typically buy—a dozen white tulips and baby's breath. Then I noticed the store had eucalyptus for sale, which I immediately bought. Instead of putting all of the flowers in one large vase, I made four different arrangements so I could spread the flowers throughout the house. Each arrangement looked so different and made me smile every time I entered a room with flowers.

Pick up a leaf, twig, or any other thing that catches your attention. Look at it from a distance—your outstretched arm is fine. Now look at it up close, really up close. Smell it. Talk to it. Honor its beauty and perfection at every stage of its life. See and appreciate new patterns of life and energy?

Notice the closer you look at the leaf, and as you zoom in, you can really see so much more of the beauty of the leaf. What do you see? Do you see the shadow the stem makes? The different veins and colors of each tiny area? What else do you notice? This is a great exercise to do any time you are out in nature, or just in your backyard.

"An idea,
like a ghost,
must be spoken to
a little before
it will appear."

Charles Dickens

Chapter 6
Business needs miracles and magic

To me, life is amazing and can be full of miracles and magic every single moment of the day. The trick is to be conscious enough to see and to create those magical days—whatever that means to you.

I know this can sound impossible once the workday begins—between emails, last-minute meetings, printers that jam when there is no time to spare, and the list goes on and on. But we don't have to forget that sense of awe once the workday begins. Want to know my secret?

All we have to do is invite miracles and magic to show up throughout the day and **to take the time to notice their handiwork.**

But what do I mean . . . what would miracles and magic look like in the work environment? It is when the person you are scheduled to meet with at 10:00 calls to say he is running fifteen minutes late—exactly the amount of time you need to finish preparing for the meeting.

Or it may manifest in the form of a phone call. You know, when someone you need to talk to—who is impossible to reach—calls you for a favor that you can do in less than a minute. I call that magic.

It is reading an article in a magazine that you have never seen before while waiting for your doctor's appointment that triggers a simple solution to a problem your team has been wrestling with for weeks.

Most people define these types of events as luck, synchronicity, or most often as a coincidence. **I prefer the terms miracles and magic, because those words are much more fun** and imply that the hand of God, his angels, or my higher self are involved in coordinating these events.

Since many people don't believe in miracles, magic, or synchronicity, **they refer to such events as a coincidence** without giving the event much more thought. But, by seeing these events as magic and miracles you instantly feel lighter and happier—just like you have a really cool secret.

What is a coincidence? It is defined as, **"A remarkable concurrence of events or circumstances without apparent causal connection."**

Wikipedia states: "A coincidence lacks an apparent causal connection. A coincidence may be synchronicity, that being the experience of events which are causally unrelated, and yet their occurrence together has meaning for the person who observes them."

That last phrase—**has meaning for the person who observes them**—nails it. It is as though synchronicity is custom designed for a specific person, not a generic, one-size-fits-all solution that appears to save the day.

So how do you make synchronicity happen more often? First, invite your guides or higher self to help you **begin to notice** all of the coincidences that do occur already—especially the ones you have never noticed.

Second, make up games throughout the day calling miracles and magic in **to support your intention**. Here is one game I play. **I intuitively decide how long a task will take**. Then I set my cell phone's stopwatch for that length of time and see if I can get the task done within that time frame or quicker.

Third, know that everyone needs miracles and magic daily, whether they know it or not. So see yourself playing an active role in creating miracles and magic for others. Have fun with it. Pretend you are psychic. Tune into what another person needs and start a conversation around that topic and see how the other person reacts. You never know.

Be generous with your compliments, feedback, time, insights, and contacts—you may never realize just how valuable what you shared can be, or that one simple piece of advice may stay with them for the rest of their life. So decide that you will be an angel to another person—without a costume or wings.

And finally, thank the Universe, God, your higher self, or whatever name you are most comfortable with, for these events and insights that appeared and for the fact that you actually noticed that they did occur.

What I consistently find is that the more I notice and am grateful for synchronous events or insights, the more I realize that most of the major events in my life are the result of them. Here is what I believe to be the secret of increasing the times synchronicity occurs on a daily basis.

Just by simply noticing, knowing, and appreciating the power, joy, and magic of synchronicity makes the Universe like you more and want to play with you on a consistent basis. That's my story.

Did you know that The Universe, God, or whomever is constantly sending you messages—using a method that is faster than email—hoping to make you feel connected to life, more appreciative, and able to smile more? **It is true.**

Here is an example of synchronicity in my life. Having practiced meditation and mindfulness for years and having done extensive research for the chapters on Meditation and Mindfulness, I was ready to begin writing that chapter one morning. But after printing out an additional sixty pages from the Internet on those topics, I lost my momentum. You know how one Internet query can suck you into a powerful energy vortex that operates beyond time and space, causing hours to evaporate without either your knowledge or consent?

Suddenly realizing that it was after 4:00 p.m. and that I hadn't written anything yet, I decided I needed to change gears and start working on the chapter on synchronicity instead—thinking it would be easier and more fun to write, because I didn't need to do any research on the Internet--or so I thought.

Then the Internet's imaginary sucking sound began all over again and I found myself lost in the vortex once again. This time, though, I consciously limited myself to reading just one more article or buying just one more book on synchronicity, and only if it looked fabulous.

Then it happened. I was guided to order a book entitled *The Power of Flow: Practical Ways to Transform Your Life with Meaningful Coincidence* by Charlene Belitz and Meg Lundstrom. After discovering that the paperback version wouldn't arrive for **three whole days**, I decided to download the Kindle version as well. Simple, right?

Not so. The Universe up and hid my iPad—I'm not kidding—and hid it exceedingly well! I had seen it at least four times that day, and since I had never left the house I knew the Universe was toying with me. In situations like this, **I generally just smile, shrug my shoulders, let go and move on. I never get mad, upset, or annoyed—I simply choose to see the humor in it.**

But on that day I proceeded to spend the next twenty minutes trying to find my iPad so I could read this new book on-line. Did I mention that I am a Leo and that **when I want something NOW, NOW is never soon enough?** I must have called my cell phone from the land line a dozen times in my quest to find the iPad, which also rings when I get a call—and even then I couldn't locate it.

Not one to be easily deterred, I finally realized that I could read the book on my old MacBook Air, while simultaneously settling in to work on the chapter using my pretty new MacBook Pro.

When I opened the Kindle app on my MacBook Air, the page that appeared was where I had stopped reading *Raising Our Vibrations* for the *New Age* by Sherri Cortland. It was a book I probably hadn't looked at on any computer or device for over a year and one that I didn't even remember owning. Here is what was on the very top of the page:

Chapter Twelve
Synchronicity: Messages to Help Us Evolve

Is that cool or what? You can't make this stuff up. While it was a simple event, it made me smile, give thanks, and interpret the incidence as a mini miracle that let me know I was on the right track and that all of the information I needed for the chapter and for all chapters would be channeled from the Universe or made available in a fun manner. Here are some other events or miracles I manifest that might make you smile, because many of the same types of things have probably happened in your life:

Thinking of a person you hadn't been in contact with for months or years and having the person call a few minutes later. **Getting the perfect parking space.** Receiving money you didn't expect. Being introduced to a person with information you needed. **Being introduced to a new restaurant, food, or recipe** that you love, love, love! Buying something that you planned on buying at full price, that is now 50% off.

I am sure you, too, have been touched by synchronous events in your life, even if you chalked those events up to being lucky, or just strange coincidences—like getting the perfect parking place. Since I had been guided to that book on synchronicity, I decided I had better read the chapter. Clearly it would contain exactly the insights I needed to talk to serious business people.

The following are direct quotes from Sherri Cortland's book: *"So what exactly is synchronicity . . . what does it have to do with raising our vibrations?"*

First, let me go straight to a definition of synchronicity that Mary Soliel found in the May 2006 issue of *The Center for the New Age Newsletter* and included in her book, *I Can See Clearly Now: How Synchronicity Illuminates Our Lives.*

"Synchronicities are people,
places, or events that your soul
attracts into your life to help

152

you evolve, or to place emphasis on
something going on in your life.
The more consciously aware you
become of how your soul creates,
the higher your frequency
becomes and the faster you
manifest positively.

Synchronicity is accelerating,
begging for our attention . . .
particularly since the dawning
of the new millennium, as we are
moving quickly toward great change
and ultimately a more peaceful world . . .
once you 'get it'—that you are
receiving, actually attracting
communications from the Universe . . .
your whole life transforms into a
magical, fascinating, and joyful journey."

Mary Soliel

Synchronicity

If you are resisting the idea that we can raise our vibrations to attract more synchronicity into our lives, that is fine. Just decide all magical things that occur in your life are luck, or based on your hard work. But remember, when something seems to occur out of the blue, it may be your cue to slow down, think about the message, insight, people, place and/or opportunities it may bring—if not immediately, perhaps in the near future—and give thanks. **Another way to re frame these types of occurrences,** which may or may not be synchronistic, is to see them as puzzles for your brain. If you

are a visual person, keep a stack of index cards in your desk draw or use the Notes app on your phone so the next time you meet someone new or a colleague says something that triggers an idea or an event seems worth remembering—even if you have no idea why—write or record these events and the essence of the occurrence, such as:

- The person's name and contact information. If you have their business card, scan it into your phone with one of the many free apps, or staple the hard copy to the back of the index card.
- Record the date, the key details of the conversation, the company the person works for or has worked for, their area of expertise, or simply their spouse's name and their children's names and ages.
- People you know in common and any other coincidences.
- Common interests you share.
- Did you promise to do or send them something?
- Intuitive insights or reaction to the person or meeting.
- Is there something you could do for that person ?
- Is there some way they can assist you?

If anything occurs to you regarding this "out of the blue" event, you can make note of the synchronistic connection and take appropriate action.

Oftentimes, you may see the value of the connection within a matter of minutes, hours, or weeks.

Once you stop dismissing these types of events and start seeing them as mini-miracles or messages from the Universe, the more often they will occur. You may also realize that dozens of occurrences were there every day that you probably missed. You can decide that these events were choreographed by your higher self, or came from the Universe (or from your Aunt Mary who passed away, if that works for you). Just pick one.

Smile and thank the Universe, just because.

Are you missing the big picture? Step back and look at a broader perspective of synchronicity and the role it has played in your life. Think about people you may have thought you met by chance and how they may have been instrumental in getting you a new job, or introducing you to your best friend or future spouse years later.

Re frame that story in your mind, to now see it as the Universe planning thousands and thousands of chess moves in advance so you would always be at the right place at exactly the right time. If that concept doesn't blow your mind, let it percolate for awhile without passing judgment on its validity.

My belief is: **The more I notice, acknowledge, appreciate, and am grateful** for every event or person that comes my way (no matter how circuitous the route may be), **the more it raises my vibrational rate.**

Why does a person's vibrational rate matter? The higher the rate your energy field vibrates, the faster you are able to manifest magic and miracles. **Smiling is an easy and natural way to raise your vibration.** Sending love to people you don't know but pass on the street, to all of the people

in all of the hospitals in the world, to countries that are war-torn and impoverished, to Mother Earth who needs your love, to Father Sky for all the stars, and to all the wonders beyond your sight and your imagination, makes a difference.

Send love to yourself and to all those people you may view as annoying, boring, stupid, or the competition. That, too, gives you brownie points.

As I experience more and more profound synchronistic occurrences these days, I often wonder just how many events or opportunities I missed.

But there is more to synchronicity

Guess what? Synchronicity isn't always about you. Think about it. How often have you found yourself telling someone about something that seems totally irrelevant, only to have him or her thank you and let you know that the information you provided made a difference in how they viewed the world, dealt with a pressing personal problem, or finished a report they were procrastinating about?

So the next time you are ready to edit yourself before you share something that may sound odd to you—especially if what you were going to share seems strange or too personal, and comes to you from out of the blue, be brave and share what came through you without attachment to how the other person reacts, or worrying about what they may think of you.

When you open your heart and come from a space of service, things shift. You feel happy inside. You feel good about yourself and find that you are more open to helping others. The more authentically caring you are, the more people will appreciate you and want to be there for you in return. It is a win-win energy that makes people more creative, playful, and fun to work with and be around.

156

Transform the mundane just by smiling. Synchronicity doesn't have to be about anything major or life-changing. For example: how do you choose which line to queue up in at the grocery store? Do you look for the shortest line, or the one closest to the exit? Or maybe you don't consciously choose. Perhaps the Universe sends you to a specific line so you can talk to someone special there or appreciate the cashier by complimenting him or her on their appearance, the job they are doing, or anything else that seems appropriate.

As I check out of the supermarket or TJMaxx, I smile, make eye contact with the cashier, and start a brief conversation. I may ask the person their name, repeat it, and either comment on the name—if it is unusual, distinctive, or charming—or pay the person a sincere compliment. I may ask them a question that requires more than a yes or no answer, or share something about myself that's related to the items I am purchasing—it is generally about the excessive amount of cat food I am buying.

As I have two cats and at least three spare (you do the math), so I buy massive amounts of cat food. I ask the cashier if she has pets, or joke that because I am a vegetarian, my food bill only goes over $150 when I'm buying food for my felines, and that it is less expensive to keep me alive than it is them.

Even one simple comment can start a conversation that may make a difference in the life of a total stranger, or at least help break the monotony. I find that when animal owners have a chance to share something about their pet, it makes them happy. So this little interaction or conversation lets me acknowledge that I appreciate the service that person provides. It also makes me feel good . . . vs. getting annoyed at how long the line is taking and muttering asides like, "Don't they know I'm in a hurry?" or whatever self-centered drama I could make it about. Anyway, where would that leave me? Experiencing negative emotions lowers our vibration, leaving us less open to the creativity that comes from our higher selves or other dimensions.

When in doubt, ask your inner knowing for guidance as to how you can serve each person you meet. With a little more banter, it may become obvious that you should recommend a book, a website, a yoga class, a headhunter, or a good massage person. Try not to edit or censor what comes to you. While it may seem strange to your logical mind, trust your gut. The information you impart may be exactly what that person needs.

Talking isn't always necessary, but smiling at those in line helps make them smile at the person next in line. When doing even the most mundane tasks, remember to be patient. Slow down, take a moment to observe your surroundings, the people and all things, even the items you think are inanimate. Give thanks for everything and everyone who is here to serve you. This, too, earns you brownie points, which can be redeemed for Creativity points.

One of my mantras is, **"I am a clear and open channel for the Love and Light of the Universe. May I always come from love, compassion, and selfless service."**

Keep the circle rolling. What makes synchronicity really magical is when an event occurs, or you see something that immediately reminds you of something you should do or someone you should call, and you actually do it. While the flash of "what you should do" is easy to ignore, you never know what acting on that thought will result in—if not instantly, the near future. Another way synchronicity can show up in your life is when you're invited to an event and you really don't want to attend, but you feel compelled to accept the invitation and to go anyway. You may just be surprised at who you may connect with.

Here is how I met my husband. When I first started my advertising/branding firm in Princeton, NJ, I decided that joining the Princeton Chamber of Commerce would be a great way to meet people and identify potential clients. That was back in 1984. After attending about six luncheon meetings

that first year, I decided there were no real business prospects, because most of the members seemed to be either insurance sales people or real estate agents with the same reason for attending.

But there was one immense advantage to being a member, of which I took advantage—I could get medical insurance at a great rate. There was only one catch. In order to take advantage of the group plan, I would have to maintain my membership and pay the yearly dues, even though I knew I wouldn't be attending any of the events.

Back in those days, before email and the Internet, every month I would receive a #10 envelope stuffed with different-colored sheets of paper, each promoting a different event that month, such as: a breakfast meeting, a luncheon meeting, an after-work networking event, and other community happenings. Most months the envelope went straight into the garbage without even being opened—until one envelope "talked" to me. I have no idea why I felt compelled to open it, but I did. I must have been procrastinating about something else I should have been doing.

As I quickly thumbed through the inserts, a postcard fell to the floor promoting a networking event at a local country club—one that I was curious to check out. The event was in mid-November and since it gets dark early, I knew I wouldn't feel like going out at night, but the event stayed with me. On the day of the event, a little voice kept telling me over and over again that I should attend. Each time I thought, "No. I don't want to be bothered." But finally, curiosity got the better of me.

Finally, I got dressed and drove to where I thought the country club was located, only to find the club totally dark and deserted. My inner, self-righteous voice said, "See God, I knew this was a total waste of time." Just then, a police car pulled up to see if I was okay.

The officer kindly proceeded to tell me that I was at the wrong country club and where the right one was. Who knew there were two country clubs I hadn't been to? Now that negative voice many of us may be familiar with said, "See, I told you this was a dumb idea and a total waste of time!" But at this point, I chose to drive the additional five miles to the other club, just to see it. Had I known the event was actually ten miles away, I may have not gone. But I was already dressed, in the car, and (I believed) halfway there, so turning back seemed impractical. Turns out I couldn't find the second country club—remember this was the "olden days" before GPS.

Even though I thought I was following the officer's directions I couldn't find the country club. In fact, I drove back and forth on the main road several times without seeing a sign for the club. The networking event ran from 6:00 to 8:00 and since it was now 7:45 I decided to bag the idea of going, and instead to stop for some frozen yogurt, proving to the Universe that I'd been right all along and that going to the event was a total waste of time.

When I asked the owner of the yogurt shop if he knew where the club was, he informed me that it was just down the street, directly across from the strip mall I was in. Since the silly voice in my head was still trying to bully me into going, I told the voice, "Okay, I'll go, if only to show you what a stupid idea this was."

Walking into the country club at 7:55, I saw people in the distance that I didn't particularly want to talk to—especially since I still didn't want life insurance or a new house! So I joined a group, closest to the door, where a tall, elegantly handsome gentleman was holding court. His name tag read—Corky, Datacon, Inc.—which indicated to me that his company was high-tech. So obviously I decided he needed a brochure.

Interestingly, two of his business associates had dragged him to the event, and had arranged to have drinks afterward. Ten minutes after I joined

the group the event was over, and Corky invited me to have drinks with his colleagues. I thought this was great since I thought he would definitely become a new client.

On our first date a week later, Corky mentioned that in a week he was going to visit family in South Africa **for three weeks**. On our second date, I met his timid cat, a big gray Siamese named Max who hid behind the microwave the first time we met. When I asked who was going to take care of Max while he was away, he said he was going to board the cat. Since I have never boarded a family member, I volunteered to take care of Max, even though I had a 150-pound Russian Wolfhound who was also named Max. The two Maxs became friends and the tall man became my husband.

Did you know that the Universe is constantly sending you messages?
Using a method faster than email—making
you feel connected to life and smile more

Every day the Universe sends you messages, perhaps signs of encouragement to let you know you are on the right track, that everything will all work out—or maybe just small messages that make you smile.

These messages come in many forms. Some people call them signs, coincidences, or mysterious synchronicities, while others may not notice them at all—like finding the perfect parking space, or seeing 11:11 all of the time on your digital clock—or any other number that is meaningful.

On most days I look for my regular signs, which may include:
Spotting a bright red cardinal, which I have decided means good luck.

Knowing who will call before the phone rings.

Someone asking if I need anything from the store twenty minutes after I decided I need farro, but was too lazy to go out.

Noticing double digit numbers like: 11, 22, 33, 44 . . . or 11:11 or 2:22 on digital clocks or on licenses.

Finding important information in a book that appears on a page with a double digit number such as: 11, 22, or 33. I also include any other double-digit numbers and numbers that are special to me, such as: 9, 13, 18, 29, 88, 108, or 144.

The real purpose of this game is to make you more mindful, in the moment, and more observant—all important aspects for developing your creativity. The game also puts you in a realm of playfulness and laughter (or at least smiling) when a message is delivered.

Other ways you can receive guidance

Need a word of wisdom or encouragement from the Universe from time to time? No problem.
- Think about an issue that concerns you.
- Now find a book, any book from the library, bookstore or your own collection—and think again about the issue.
- Open the book to any page. Pick a sentence or paragraph and read it.
- If you want to use Amazon.com or BarnesandNoble.com, just enter one or two words on a topic, see what books come up, pick one that has the "look inside" option, scroll down to any sample page, and read a sentence or two. You may just be surprised.

Then again, you may not get an obvious answer the first time you try this, but over time you may master this technique. Worse case, you may discover a book or two worth reading.

Go shopping. There are many interesting books and card decks you can buy that are designed to give you guidance. Amazon or Barnes and Noble on line are generally the best places to find the most extensive selection of books and decks—unless you live in Sedona, Arizona, or somewhere that has a great metaphysical book store close by. On Amazon you can search by using the words, "card decks for guidance." You will be amazed at just how many card decks exist. One of my favorite card decks is *The Mayan Oracle* by Michael Bryner and Ariel Spilsbury or their more recent version, *The Mayan Oracle: A Galactic Language of Light* by Ariel Spilsbury and Michael Bryner.

Create a palette of colors that make you smile

- Go to Lowes, Home Depot, or a Benjamin Moore Store and select an assortment of paint chip samples that appeal to you.
- From this pile, pick out one or two colors a day and see how many items you notice that match those colors.
- When you find an item that matches, you get to decide what it means. It can means you are doing good, are on the right track, be patient as a surprise is coming today, or anything else you want. You're in charge, and you get to make it up.

Here's another colorful way to enhance your creativity. Take a few color chips with you grocery shopping and see how many colors you can match. Don't be concerned if the color chips are an exact match.why? Because the colors on the paint chips are printed using a different printing process than the colors you will see on labels and boxes in the store.

Appreciate every moment and give thanks

A great way to enchance creativity is by taking photos for no special reason, other than that you notice a beautiful leaf, the bark of a tree, a weed up close, a flower, the sky at dusk, sunsets on a rainy day. Taking pictures of your pets, children, or buildings that have great architectural elements are always great to notice and capture.

I even like taking pictures of even the more mundane items we generally don't take notice of, like signs, garbage cans, wet newspapers, dirty boots, stuff around my house—you get the idea. Here are three of my favorite models that I just happen to be related to!

Colton Floria-Callori, Kendall Moll, Lynne Hoinash, and Decker Floria-Callori

"Tap into the secret
power of your hands.
Unleash your
creativity and
enhance your life."

Lynne Evan Hoinash

Have fun learning new skills

Here are three tools or techniques that you probably aren't familiar with:

Mudras
harnessing the power of your hands without anyone noticing.

Pendulums
accessing your inner knowing within seconds.

The Power of Sound
how music, sound, tuning forks, sound, and
Tibetan singing bowls can change your state of consciousness.

Select the one that sounds the most interesting and come back to the other two later.

Mudras

While you may not be familiar with the word, if you have ever meditated or practiced yoga, you have probably used one or two mudras without realizing it. Think of the hand position generally held while sitting meditating—where one open palm is gently resting in the other on your lap, with both palms face up, or when you hold your palms against each other, positioned vertically over your heart in the center of your chest. Both these are mudras.

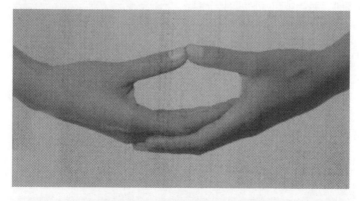

Best explained by Nadine Dassier, in her article, *Three Mudras for Everyday Magic,* she states, "Mudras are hand and finger postures that quickly move and redirect the flow of energy within our body, mind, and spirit. You can shift your consciousness and revitalize your organ systems in a matter of minutes by practicing these sacred hand gestures. "

The great thing about learning a few mudras is that no flexibility is required. Many are hand positions we normally use without knowing they are considered mudras. And, because of that people won't realize you are actually harnessing the magic of your hands during meetings, while on conference calls, or during interviews. There a many ways to learn more about mudras—from books and from YouTube videos.

While there are many great books on mudras, my favorite method for learning mudras is from a deck of flash cards by Cain and Revital Carroll called *Mudras of Yoga.* Cain Carroll is a teacher, speaker, and author in the field of self-healing and spirituality, and Revital is an internationally acclaimed performer and teacher of Classic Indian Dance. This seventy-two-card deck presents some of the most important hand mudras used in yoga to support mental, emotional, and spiritual development, along with having health benefits.

The beauty of this card set is that the accompanying booklet lets you quickly choose a mudra for specific issues, such as: addictions, anxiety, brain vitality, clarity, common colds, compassion, constipation, courage, depression, emotional balance, rejuvenation, fear, spiritual awakening, weight loss, and wisdom.
The cards are beautifully

designed, and it is easy to keep one or two of them with you to practice while at meetings or on phone calls (while using the speaker setting).

You can order the set along with Cain Carroll's other books at caincarroll.com or on shaktibhakti.com. According to the Carrolls . . . a mudra is a 'gesture,' or 'seal.' In this context, the word mudra denotes a sense of evoking a hidden power or uniting with something larger, such as the field of universal energy (Shakti) or the principle of pure awareness (Shiva)."

Since mudras are ancient and were practiced in many cultures, there are various hand positions that go by the same name. Conversely, there are many identical mudra positions that go by different names. Don't let this bother you. Experiment with a few that call to you and use the ones that work for you, regardless of the name.

What are the benefits of using mudras in a business setting? Imagine. You are sitting in a meeting. None of the ideas being tossed around seem to make sense or address the real issue. What is even worse is that you can't think of a politically astute way of shifting the conversation to refocus the discussion. As you realize that not contributing looks even worse, you start feeling anxious.

Then you remember that you have been carrying around six very specific mudra flashcards that you've been intending to memorize, but haven't gotten to yet.

You quickly glance at them, and you are relieved to remember a few of the hand positions look normal and can be done with your hands on the table. For those slightly odd-looking mudras, you can do them while keeping your hands on your lap, well hidden under the table.

The first mudra you select is CLARITY. Here is what it looks like:

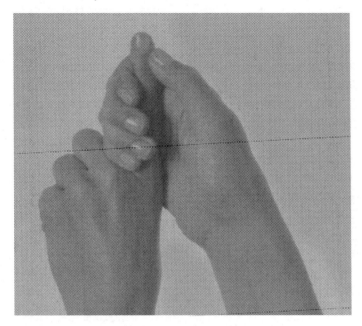

You smile because this is an easy mudra to do. You take a few deep breaths, copy the finger positioning for clarity with your hands resting comfortably on your lap, and in less than two minutes you suddenly realize why the meeting isn't going anywhere. The members of the group aren't all clear about the long-term goals, but you are, and you're thankful that this ancient practice has worked as promised.

Suddenly it is now apparent what you need to say to get everyone focused on the real issue. You proceed with a new sense of calmness, clarity, and conviction.

Now that everyone understands the real issue, it's time to access your **INTUITION**. Luckily the mudra for intuition looks like a normal hand position and can be done with your hands on the table. As your intuition kicks in, new ideas instantly flow and your presentation of the ideas is flawless.

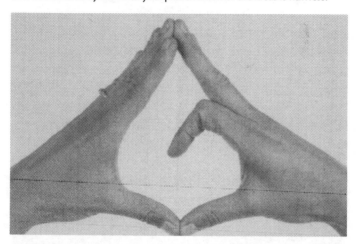

Suddenly, everyone is energized and they begin to rally around your ideas and start contributing. Surprisingly, the meeting is done in half the time allotted. You look at the mudra card again, shake your head and wonder if it really made a difference. Maybe now you will memorize a few of these mudras and learn more about mudras.

Mudras can assist you in many ways? They can:
Mentally —improve your focus, memory, reduce stress, and give you more willpower.

Emotionally—ease anxiety, fear, depression, and restore a sense of balance and well being.

Physically—increase flexibility, overcome pain, deal with common ailments, and aid with more serious illnesses.

Spiritually—mudras can be used while meditating, they can help you feel more centered, enhance intuition, and support spiritual awakening.

Here are a few other examples of times where you can use mudras. For new insights and inspiration. You are writing an executive summary to sell the idea of introducing a new service to your existing client base, along with developing cost projections for hiring the people and leasing equipment. Even though you assumed you could knock this summary out quickly, you are annoyed to find that you are struggling to get it done.

Solution You take a few deep breaths—the kind that makes your belly rise and fall and begin holding the mudra for **INSPIRATION**.

Close your eyes, keep breathing and relax. After a few minutes, the hand position helps you see how to restructure the summary to make it work.

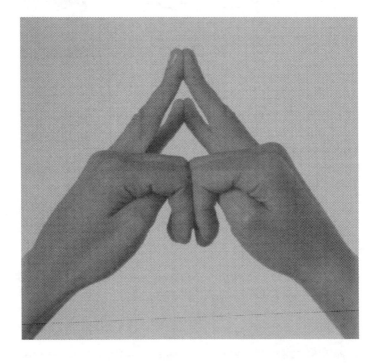

This mudra will calm your emotions and rally your COURAGE.
For example, you have to make a presentation to senior management and anxiety is getting the best of you. Then, you remember there is a mudra to defuse anxiety. The same mudra also is good for fear and stress. As you hold the mudra, you close your eyes and visualize yourself being calm, clear, courageous, convincing and impressing the group.

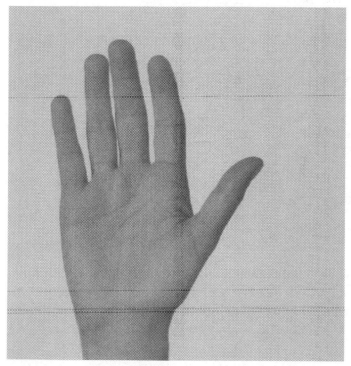

This seems to make a huge difference. You can also practice similar mudras for: tranquility, courage, clarity, vision, creativity, communication, or creativity.

To access your CREATIVITY.
You know creativity is what is called for to develop new products and product enhancements to your existing product line, but you have no ideas. In this

situation you can hold mudras for: clarity, vision, intuition, or creativity. **Here is the mudra for CREATIVITY.**

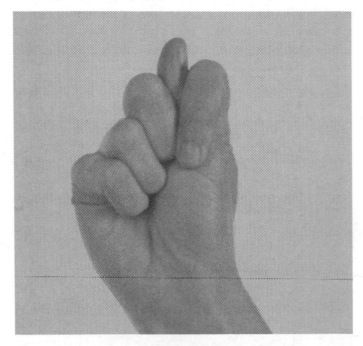

While holding these sample mudra positions may look quiet simple, there is much more to learn about each of the mudras in Cain Carroll's card deck, *The Mudras of Yoga* to maximize their effectiveness. On the back of each card is detailed information describing the technique, the application, along with the benefits.

Setting your intentions makes a big difference

Whether you are learning mudra hand positions, working with a pendulum, experimenting with tuning forks, or doing any other activity, it is important to understand the value of setting your intention.

Your intentions are what you want to see happen, whether it is for the outcome of a meeting, what the finished report and the quality of its contents looks like, or anything else you want to accomplish in business or in life. **Here are a few secrets to remember when setting your intentions:**

- **State the outcome as something that is already accomplished.** Instead of thinking, I want this meeting to go well, think, this meeting was extremely successful.

- **Visualize** what "extremely successful" looks and feels like, and be very specific. Such as: see in your mind's eye that everyone came to the meeting with lots of energy and enthusiasm, that the right people attended, that your solution was strategic and perfectly aligned with the corporate mission, that the approach ensured that the project would come in under budget by at least 11%, and that the plan was supported by all in attendance.

- **Feel exactly how you will feel** as if everything has already turned out perfectly. "Feel it real," is what you want to do. The more you can feel just how good you will feel when X is accomplished, the more you can count on it happening. Don't get hung up on trying to figure out all of the steps of how it will come to be. Rather just visualize the end results as already accomplished. Feel yourself smiling, relax and give thanks.

- **Let go of any attachment** you may have knowing how the results will transpire. Just KNOW that your intentions are already realized and that everything will come to pass.

"It is through science that we prove,
but through intuition that we discover."

Henri Poincar

175

Pendulums

Using pendulums is a fun way to access your inner knowing because you are bypassing your brain—and you don't have to believe that it will work.

The pendulum is a powerful tool for tapping into your intuitive knowing.

What is a pendulum and why should I care? Basically, a pendulum is simply a weighted object suspended from a string. It is a powerful, fun tool for enhancing your creativity and innovation.

There are thousands of types of pendulums. The only differences between them are size, shape, design, and the material from which they are made. They all work the same.

Here is a sample of the various types of pendulums available today. You can even use a key suspended from a piece of dental floss. It is also easy to make your own pendulum using simple beads, like the ones below.

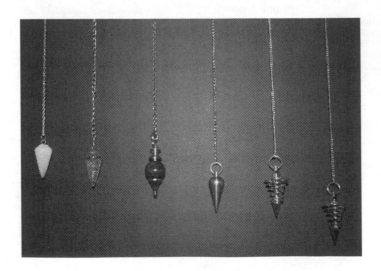

Who first used the pendulum? The pendulum is not merely a "new age" gimmick. It has been an invaluable tool throughout the ages for helping people to make decisions. Archaeologists have found clear evidence that civilizations as far back as 8,500 years ago (Egyptians, Hebrews, Persians, Etruscans, Greeks, Druids, Romans, Peruvians, American Indians and Polynesians) used the pendulum to access information from other dimensions.

Who can work with a pendulum? Everyone. You don't need any special talent. In fact, you can be a skeptic—totally certain it won't work for you. Countless executives and PhDs who consider themselves to be hard-nosed business professionals have picked up a pendulum just to prove it doesn't work. Lo and behold, within a few minutes they were shocked as the pendulum moved in response to their verbal or nonverbal commands such as show me **YES** and show me **NO**.

Ensuring your success. Remember when working with a pendulum to relax, let go of expectations, be patient, and have fun.

When you first start working with a pendulum, the key is to ask simple questions that require simple, direct "yes" or "no" answers. Remember: You have nothing to lose, because you don't have to act on the answers you get.

While the pendulum can be helpful, you don't need to rely solely on the answers it provides, especially in the beginning. Use your own intuition, intelligence, and common sense when making important decisions.

Here is how to start. All you need is a piece of string with a weighted object at the end. You can use a pendant or ring suspended from a chain, or a house key suspended from a piece of dental floss.

Keep it that simple. It is important to first establish how the pendulum communicates with you. The pendulum can swing or move in four directions: The pendulum doesn't move in the same direction for everyone.

When the pendulum moves in a circular motion, either clockwise, or counterclockwise, that may indicate that the answer is maybe, or ask this question at a later time.

It is important to first, determine which direction or movement indicates YES and which indicates **NO** for you. One type of movement isn't better than any other. Here is how to begin working with your pendulum. Hold your pendulum in your dominant hand, using your thumb and middle finger to hold the string about four inches above the weighted object. Rest your elbow on a table or flat surface to keep your arm steady.

Hold the pendulum still and say, either aloud or to yourself, "Pendulum, please show me YES."

Give the pendulum time to respond, and observe the direction in which it swings. Once the pendulum starts moving, ask it to show you YES more strongly.

Now do the same thing, this time asking the pendulum to "Show me NO."

Now ask the pendulum to "Show me MAYBE."

For most people the YES answer is forward and back. For others, yes may be indicated as a left to right movement. Which ever answer you get for "show me yes" is the opposite for "show me no." It can move in a clockwise circle, which generally indicates YES. It can move in a counter clockwise circle, which generally indicates NO. Ask your pendulum several questions to see how it responds to you.

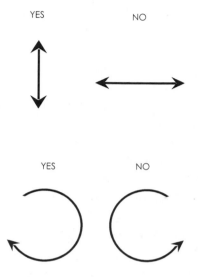

Do this by asking your pendulum a few simple questions you already know the answer to, such as:

- "Is my name Sam Smith?" This should result in a NO response, unless your name happens to be Sam Smith.
- "Is today Wednesday?"

Once you have determined how your pendulum communicates, start asking it all different types of questions that only require either a YES NO or maybe answer, such as:

- Is Quaker Oatmeal better than the store brand?
- Is the name brand product worth the extra money?
- Should I invite Jane to go to the movies with me today?
- Is this dress/suit too fancy for tonight's occasion?
- Should I update my resume?
- Should I invite Phillip to the marketing meeting?
- Is March a good time to take my vacation?
- Is this book worth reading?

You can use your pendulum to further clarify an answer. For example: regarding the last question—Is this book worth reading? If your pendulum says YES, you might want to then ask:

* Should I buy this book? —See what answer you get. Then ask:
* Should I get it from the library?

In some cases the pendulum may not indicate a strong preference, either way, so you decide.

The simple act of playing with the pendulum opens your mind to a new level of insights and answers. It also moves your thinking to the right side of the brain and puts you in a playful mood.

You can use this tool anytime it feels appropriate.

Now that you've mastered the basics, the real fun begins. Here is how you can ask more complex questions by creating charts.

Charting for more information. You can use pendulum charting to ask all types of business questions including those regarding budgets, people issues, processes, projects, technology, timing, etc.

Charting is a great problem-solving tool that saves you time, helps you to make better decisions, and facilitates access to your subconscious mind. When you have a question, the simple act of creating a chart helps you tune into your intuition as you lay out multiple options, some of which might not initially have occurred to you. A chart helps you to:

* Visually see just how strongly an answer to a question appears
* Determine the order in which you should do various projects
* Establish how much time you should spend on each project
* Develop a structure within which to solve problems
* Assemble the best people for each project
* Motivate each member of the team

I frequently use pendulum charting, especially when I find myself:

- Procrastinating
- Needing goals
- Lacking structure
- Unsure of how to solve a problem
- Wanting to make working more fun

Here is how to create the initial chart. First, determine your question or goal. For example: today there are six things I want to accomplish (and not necessarily through to completion today). Rather, I want to get enough done that I have a sense of accomplishment and momentum.

I would draw a chart with six lines radiating out from the center. If you have three things to do, draw three lines radiating out from the center.

Next, label each of the six lines with a task—one per line. There is no right or wrong order in which to enter the projects. You can shorten the name of each, as long as you know which project you are referring to.

Set your intention. Here is an optional step. As you add the name of each project, decide what you want to accomplish. This doesn't need to be a long and involved left-brain thinking process. Rather, jot down whatever comes to mind. Keep it fun and light, knowing that you can change your mind whenever you like.

You can have more than one intention for a project—it doesn't really matter. So listen to all of your intentions and ask what would make doing your project fun and rewarding.

Decide on the order in which to place the items on your chart. Ask the pendulum to show you which project you should tackle first to be the most _____ . Fill in the blank, based on your intentions.

Here's how. Hold the tip of the pendulum over the center of the chart along the baseline where all the lines converge. Ask your higher self which project should come first, second, third, etc. and make note of the order.

As your day proceeds, you may intuit that the order should be changed, an item should be eliminated, or a new item added. When this happens to me, I adjust accordingly without any attachment to my initial plan. I am still listening to the same sense of knowing that I did earlier in the day. I don't get upset. Rather, I trust that everything is always perfect, even when I can't see the perspective from which it is perfect.

Establishing the amount of time to spend on each project. If you want to know how much time you should spend on each project, create a time chart based on the range of times that seem appropriate. Keeping your intentions in mind, ask the pendulum, "What is the optimal amount of time to spend on this project right now?"

Here is how my final chart may look. For me, having a time frame gives me a structure and just enough pressure to stay focused. It's also fun to see if I can get a specific project done in a certain amount of time. When I'm really in an OCD (obsessive compulsive disorder) mode, I will set the timer or my cell phone just to see how close I come to accomplishing the task within my made-up time frame.

It never matters if I am right or wrong. It is just a game. Most times I run over the amount of time I predicted, but I'm still having fun, I am still entertained and I have an added dose of self-imposed pressure, which I respond well to when I work. When projects consistently take longer than anticipated, it makes me smile as I realize how much I enjoy my work once I get started and how happy I am when I get lost in the process.

As Mihaly Csikszentmihalyi writes in his book, Flow: The Psychology of Optimal Experience, "During flow, people typically experience deep enjoyment, creativity and total involvement with life." He goes on to discuss how through conscious effort and **when one is engaged in self-controlled, goal-oriented, meaningful action, a state of flow occurs naturally** and happiness is easily achieved. I believe that working with a pendulum to structure and prioritize your day helps you to enter a state of flow—a state of deep inner satisfaction and happiness, where all sense of time disappears.

How to Ask the Right Questions

Now that you know the basics of working with a pendulum, you can continue reading for additional examples of how a pendulum can further assist you in your personal and professional life or skip ahead to the chapter on sound.

You can ask all types of questions from the semi-silly ones to the very seriously important ones, such as: If I really want my presentation to go well this morning, should I have a breakfast of: oatmeal, scrambled eggs, yogurt and fruit, or Captain Crunch? It doesn't matter.

To accomplish the optimum on this project: Should I work alone or form a team?

Would Sara be an asset to the team? If so, in what capacity? As a:
- Researcher?
- Writer?
- Liaison between department heads?
- Graphic designer creating all presentations?
- Project manager?

Am I getting the information I need to create a realistic budget?

Should I increase my budget projections? If so, by what percentage? Is it time to invest in the new technology? Can I trust my new boss to be honest?

Appreciate the importance of phrasing your questions. After working with a pendulum for a while, it may be easy to revert back to asking simple YES or NO questions.

How you phrase your questions really matters. For example: Should I take this new position? Should I bring my A game to this project?

Remember that when you ask a question, it is important to include those elements that really matter to you. For example, when you think about accepting a new position, what do you really want?
- More money?
- A chance to be a part of a more dynamic team?
- An environment where your contributions are recognized?
- An opportunity to learn about another division of the company?
- A position that will look good on your resume when you want to change companies?

You get the idea. There may be several factors that are important to you and to your family, so now what do you do? You can create a chart with the criteria that's important to you and use the pendulum to rank them in order of importance.

If you are still not sure what to do create a chart from 10% to 100% in ten or twenty percent increments. Use the pendulum and ask how much each factor matters.

Use the insights you get from the pendulum as one data point when making important decisions. Talk to people you respect, do your homework, consider your long and short-term goals, trust your judgment, and decide if it is time to decide. If you still feel unsure of what to do, waiting often makes the most sense. Something better may be just around the corner. Or, by exploring other options, you may appreciate where you are much more.

Going deeper

If you want to really run through the thought process behind using a pendulum, here is an example:

Begin with a simple question:
Should I take this position? _____ yes _____ no

Record your question and answer in a notebook, or in our companion Pendulum Workbook.

Whether you get a YES or a NO response, you may feel confused about the answer. Continue on, asking more specific questions. This may give you a new level of insight, which will make the decision-making process easier. **You can also ask the same questions again a few days later.**

Here are some additional sample follow-up questions.
1. Will my financial needs be met? _____ yes _____ no

2. Will I enjoy the new position? _____ yes _____ no

3. Will I learn from the people in this new department?
 _____ yes _____ no

4. Is this position an important stepping stone in order to achieve my longterm career goals? _____ yes _____ no

Here are two examples of questions that aren't optimally phrased, and why they're not:
1. Will I learn and grow in this new position? _____ yes _____ no

2. Will my talents be used and valued in this new position? ___ yes ___no
Question 1 asks, "Will I learn and grow in this new position?"

The wording is flawed because it combines two different questions into one. One is about learning and the other is about growing. Question 2 also contains two separate elements, which should be asked as two distinct questions.

Still not sure about how to evaluate the results you just got? Try this: Look at those questions that you marked as a yes:

Should I take this position? ___x___ yes _____ no

1. Will my financial needs be met? ___x___ yes _____ no

2a. Will I learn in this new position? _____ yes ___x___ no

2b. Will I grow in this new position? ___x___ yes _____ no

3. Will I enjoy the new position? ___x___ yes _____ no

4a. Will my talents be used in this new position? ___x_ yes _____ no

4b. Will my talents be valued in this position? _____ yes ___x___ no

5. Will I learn from the people in this department? ____ yes ___x___ no

6. Is this position an important stepping stone in order to achieve my long-term career goals? ___x___ yes _____ no

Now you can create one chart to determine the order of importance of each factor and another to determine what percentage of importance each of the top three or four aspects rate.

The pendulum can be very helpful when it comes to getting a sense of timing around an issue. You can create a chart with various time frames—

this year, next year, too soon to tell. You can create a chart for the twelve months of the year, or for whatever other time frame is relevant.

Pricing issues. You can create a chart when you have money questions such as:
- What should I charge a client for a service that is fair, that honors my time and talents, and that my client can afford?
- How much money should I initially offer a job candidate?
- How much money is the most that I should offer to pay this candidate?

Other resources. If using a pendulum intrigues you, we recommend that you order my Pendulum Workbook entitled: ***Awaken the Creative Genius Within Using a Pendulum*** that is available at RedWolfDesign.com. It includes both sample questions and charts that you can use. For example, there are charts that show the months of the year, days of the week,etc. There are also blank charts that you can copy and use to ask questions and record the insights you get. Working with the pendulum may help you develop your intuition.

Using the pendulum in your personal life. Suppose you are planning to eat at a restaurant you have never tried before and don't know what to expect. Go on-line, print out the menu and get out the pendulum to pre-decide. Include in your question the day and the approximate time you will be eating.

You may find that you are equally drawn to two items on the menu and can't make up your mind. Think of what is important to you when you ask the pendulum for guidance. Instead of simply asking, "Should I order this fish dish?" Ask a more detailed question such as:
- Is the fish delicious?
- Is the fish fresh?
- Is it beautifully presented?
- Is the sauce amazing?

If the other dish that appeals to you is a pasta dish, you may want to include in your question:

- Is the pasta worth the extra calories?
- Will I have the willpower to eat only half and take the rest home?
- Is the sauce seasoned perfectly to my liking?
- Is the pasta homemade?

After a while, you will be able to just think of a question with all of the qualifiers that are important to you and use a shortcut by thinking "fish" to see if you get a YES or NO—either intuitively or with help from the pendulum. Then you might test "pasta." If you get a NO for both questions, it could indicate that you might have missed another option on the menu that is beyond fabulous. If a menu has multiple pages or lots of choices, don't ask about each dish. Instead ask if the best item is on page one, page two, or page three. Or you could just ask, "is it a fish dish, a chicken dish, or a pasta dish," and go from there. Remember, you have free will. You can ignore what the pendulum tells you—and order an appetizer as the main meal.

Sound

Harnessing the power of sound
how music, tuning forks, Tibetan bells, and Tibetan singing
bowls can change your state of consciousness

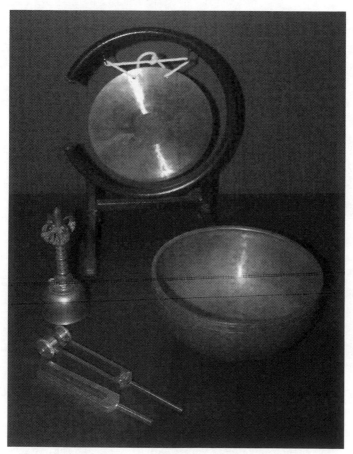

*The items on this page, starting from the top center are: a gong, a Tibetan singing
bowl, two tuning forks, and a Tibetan bell.*

The universe is sound!"

Deepak Chopra

"Sacred texts that declare:
'Everything is sound."

Jonathan Goldman, *The 7 Secrets of Sound Healing*

Did you know that you can awaken new levels of creativity and access new states of consciousness simply by using tuning forks or listening to specific music? It is true.

Jonathan Goldman, a pioneer in the field of music, tell us in his book, *The 7 Secrets of Sound Healing,* on page XXI,

"Our bodies can be tuned using sounds, music, reciting mantras, with overtone singing and other sonic modalities."

Almost all ancient cultures believed, as many indigenous peoples still believe, that sound is the creative force that brought the Universe into being. It is written in the New Testament:

"In the Beginning was the word, and the word was with God and the word was God."

(John 1:1) "The word" quite clearly refers to sound, which is the God force or creative force of the Universe.

Sound cannot only unlock your creativity. It can also enhance your well-being. It can be used to:
• Reduce stress and anxiety
• Improve concentration
• Magnify your intentions

Several companies have developed very specific tuning forks that help shift you into various states of consciousness. Three of my favorite sources for tuning forks and information are: BioSonics, SomaEnergetics, and Source Vibrations. All three sell tuning forks of exceptional quality-well worth the investment.

Who uses tuning forks? BioSonic's precision-tested tuning forks are easy to learn and simple to use, and the healing benefits are miraculous. Both everyday people and practitioners of the healing arts use tuning forks to positively alter the body's biochemistry. Sound has a positive effect when used in tandem with energy therapy practices, such as:
- Polarity therapy
- Reiki
- Massage
- Sports rehabilitation
- Yoga
- Hypnosis
- Meditation
- Pain management

Sound is a great complement to energy work, as it can restore overall health, harmony, and Inner calm. How does this work? By using specific tuning forks and other sound modalities, you can experience deep levels of inner peace and well-being. In fact, it helps you bring your body back to its fundamental pulse, which connects you to your authentic self.

Why are so many people using tuning forks?

It's fun. It's easy. It's totally affordable, and maybe most important— no lessons are required. **Think about it.** They are lightweight, easy to transport, and a great conversation starter. I even checked, and at the time they were allowed in your carry-on baggage.

With a little more research, you will discover that the use of tuning forks can be a magical instrument of love and light. For example, it:

- Provides an instantaneous and deep state of relaxation within seconds
- Improves mental clarity and brain function
- Increases your level of physical energy and mental concentration
- Relieves stress by drawing your body into a centered space
- Develops and refines your sonic abilities
- Enhances massage, acupressure, dream work and meditation
- Brings your nervous system into balance
- Integrates left and right-brain thought patterns

There are special tuning forks for a wide range of application. For example, there is a set of tuning forks that can move you almost effortlessly into any of these four states of consciousness:

Beta is associated with peak concentration and heightened alertness.

Alpha puts you in a deep state of relaxation, which is ideal for creativity, visualization, introspection, and quiet alertness.

Theta has been identified as a gateway to learning and memory. It is known as the twilight state, where we can tap into information beyond our normal conscious awareness.

Delta is associated with deep sleep, where we revitalize our body, achieve a detached level of awareness, and become open to new levels of knowing.

The following are some quotes regarding sound from the website: https://altered-states.net/barry/newsletter463/quotes.htm.

"To enter into the initiation of sound, of vibration and mindfulness, is to take a giant step toward consciously knowing the soul. There are hundreds of accurate models for this great journey inward. Each requires belief and discipline as well as the will to allow the inner and outer worlds

to relate. Listening, learning, study and practice are important tools. But we need the courage to enter into ourselves with the great respect and mystery that combines the faith of a child, the abandon of a mystic and the true wisdom of an old shaman." Don G. Campbell, *The Roar of Silence.*

According to Edgar Cayce,

"The human body is made up of electronic vibrations, with each atom and element of the body, each organ and organism, having its electronic unit of vibration necessary for the sustenance of and equilibrium in, that particular organism."

He continues, "Each unit, then, being a cell or a unit of life in itself has the capacity of reproducing itself by the first law known as reproduction division. When a force in any organ or element of the body becomes deficient in its ability to reproduce the equilibrium necessary for the sustenance of physical existence, and its reproduction becomes deficient in electronic energy. This may come by injury or by disease, received by external forces. It may come from internal forces through lack of eliminations produced in the system or by other agencies to meet its requirements in the body."

"There is a song reaching the whole earth, wrought from patience, love and prayer. Neither violent nor assertive, it is peace begetting peace, love made manifest. Listen to it with the ear of your heart; let it go deep within. Open to the sound, to the holy words, to the life of which it sings." Katharine Le Mée, *The Benedictine Gift to Music.*

"Do you know that our soul is composed of harmony?"

Leonardo daVinci

"It's something we are all touched by. No matter what culture we're from, everyone loves music."

Billy Joel

"You can look at disease as a form of disharmony. And there's no organ system in the body that's not affected by sound and music and vibration."

Mitchell Gaynor, MD, *Sounds of Healing*

"Many say that life entered the human body by the help of music, but the truth is that life itself is music."

Hafiz, Persian Sufi poet

"Music expresses that which cannot be said and on which it is impossible to be silent."

Victor Hugo

"People, plants
&
animals alike respond
to the energy
of the space,
then to the people,
&
lastly to the decor."

Lynne Evan Hoinash

Chapter 8

Setting the stage for success—
by making your space work for you

**What does this mean and how do you
make your space work for you?**

**It's simple! Just know, or pretend, that all rooms and everything in
them are alive, conscious, and can generate or hold different fields
of energy.**

That's why when you walk into some rooms or open spaces the energy
feels unsettling or disturbing, while other spaces feel warm, inviting, and
relaxing. **How is it possible for the same room to go from feeling
uncomfortable one minute to feeling warm and welcoming the
next? That's easy . . . it's because the energy changes.**

What causes this change? Many things can be responsible for creating
uncomfortable energy in the room. A heated argument may have occurred
just minutes before your meeting, or a person in the last meeting may
have been dishonest, or wouldn't share critical information, or it could be
something much simpler—like maybe the room was left a mess, which
shows no respect for the space or for the next group to use the room.

Other factors may be attributed to the mood of the people entering
the room. For example, a meeting room may feel upbeat before the
attendees arrive, but once they enter the room the energy may quickly
become uncomfortable. **Why would this happen?** Maybe the attendees
are angry, or resentful for having to attend the meeting. Maybe the meeting
is about a difficult subject, such as an upcoming layoff, or of a possible
hostile takeover.

So if you ever encounter a person who is angry, you might want to share this profound message from Buddha with them. Instead of delivering this message verbally, have the quote written out or printed on a card that you can simply hand to the person. You can say someone gave you this card and you thought you would pass it on.

"Holding on to anger
is like grasping a hot coal
with the intent of throwing it at
someone else; you are the
one who gets burned."

Buddha

When you sense negative energy in a room because of what happened before your meeting, the mood of the attendees, or the subject matter, there are some easy fixes.

First, let the attendees know that you have a sense that the energy in the room feels off and that you need their help clearing out the old negative energy before you start the meeting.

Next, make up a reason why the energy is off. For example, you can say there may have been a heated argument during the last meeting. Now ask everyone to stand up and help you move the old energy out. You do this by opening the windows and doors and having everyone use their hands to sweep out the old energy. Ringing a Tibetan bell like the one on the right also helps clear the energy.

You can also use a simple tuning fork that resonates at 528 Hz. like the one below.

Initially people may think you are crazy and may feel strange doing this, but that's okay. **Crazy can be good.** Just ask the attendees, with a straight face, for their help and watch how quickly the energy in the room shifts.

What generally happens is that everyone will go along with you. While they may initially feel stupid, this is actually fun and it does make the room feel different.

An additional benefit is that moving around feels good, and being playful for even thirty seconds enhances creativity. It also lets the group know that their meeting is starting out with good, fresh, positive energy! And, if the truth be known, you can play this game with every meeting until people come to expect to start most meetings this way!

If you are feeling brave, ask everyone to chant OM before the meeting starts so everyone is on the same page.

Before the meeting starts

Acknowledge that you appreciate everyone showing up on time. If you have the sense that some of the attendees may think the meeting is a total waste of time, remind them why the meeting is important. If you see or sense attitude or resistance from any of the attendees, don't be afraid to chide them to stop pouting, and let them know if everyone smiles the meeting will be over much sooner.

Let people know when the meeting will end. Ask if anyone needs the meeting to end earlier. If someone does, ask the group if they can intend that you get everything accomplished by that earlier time. This tactic helps people to be laser focused, and it generally works really well before lunch and toward the end of the day.

So why is this relevant?

Because everything is energy, and energy matters.

In fact, preparing for a meeting may be just as important as

setting the energy in the room. Read this again. It is important. Once you appreciate this fact, you will never walk into a meeting room or office and see it in the same way—including your own office.

Before getting into the details, think about the last few meetings you held or attended in a specific room. Can you recall if the energy in the room felt even slightly different every time you were in that room? Can you recall what it was about any of those meetings that may have contributed to the feel of the energy—whether it was positive or negative? It doesn't matter if you don't remember past meetings. Start becoming aware of energy in different rooms at work and at home.

Here is all you have to know to make the space work for you.

First set your intention.

While this may sound strange or be a new concept, knowing what it means can give you a real advantage In all aspects of your life—not just in business. If setting your intention seems simplistic, trust me, the effects can be dramatic. But first, a little background.

Quantum physics has now proven that our thoughts contain energy. Thoughts are forces. Negative thoughts vibrate at a lower, denser level or frequency. Positive thoughts vibrate at a higher level or frequency.

Every thought you have produces some sort of ripple effect—both on you and on those around you. There are also neutral or non-emotional thoughts such as, "it is hot today." This thought is neutral only if you don't care whether it is hot or cool and if you have no emotional attachment to the condition. The same exact thought could be positive if you were glad that it was hot because you were going to the beach, or negative if you were working construction outdoors or installing a roof.

"What you think you become."

Buddha

Imagine that every one of your thoughts is like throwing one rock into a pond. This thought or action has a rippling effect, and you never know who it will affect.

"A powerful intention is
like a lighthouse.
The lighthouse shines a beam of light
that acts as a beacon for ships at sea.
Following your intention and taking
control of thoughts, can give just
the direction you need to
achieve your personal best."

Kathryn Samuels

Most people think that setting an intention is the same as setting a goal. The fact is that setting an intention is more powerful because you actually think, feel, and believe what you want into existence. An intention entails seeing the end goal actualized without worrying about the details.

How so? Setting an intention adds a spiritual element to the process. Imagine when you set an intention that you are calling in your angels, spirit guides, higher self, and God, **to come help you make this happen.**

Know that setting an intention is a conscious decision as to what you want to create by when, and how you choose to feel once it happens without concern for the process. It is a powerful catalyst for manifesting specific outcomes and emotions, and it helps you make decisions. Writing down your intentions is the secret sauce that accelerates the process.

By using consciously directed thoughts we create our intention, set goals, and ultimately create our reality. But often people don't give themselves permission to set big dreams—such as being president of the United States. Did you know that many highly successful and famous people decided at a very early age that they would be President of the United States, an award-winning actor, or the best quarterback that ever played? It's true.

They succeeded because they set these intentions long before society could tell them that they weren't good enough, or were the wrong sex, or color.

Why is it important to set powerful intentions? It is because almost all people have limiting beliefs, and positive intentions help us overcome these beliefs.

Don't feel bad if you discover that you have limiting beliefs. You are in good company. Everyone has them to varying degrees. Most of our limiting beliefs were formed before we were seven years old.

Often these limiting beliefs were imposed on us based on our parents' limiting beliefs that came from their parents, or based on societal norms. More than likely many of our beliefs stem from something we overheard as a child—such as: he'll never amount to anything, it's sad that she didn't get her mother's looks, he will never be successful with that attitude, he is so lazy, her brother is the smart one. By the time we are seven, we may truly believe these statements are true. That is why many people have an underlying sense that they will never amount to anything, they are not lovable, or they are not enough.

It is time to let go of these limiting beliefs that aren't true, because they prevent you from being who you truly are.

Remember that energy flows
where intention goes. So always
focus on what you desire—especially
if you think it is impossible. Just tell
God to make everything come
together impeccably so, and
with perfect timing.

Here are a few more things to know about limiting beliefs. Since negative beliefs can easily sabotage your ability to set powerful intentions, they must go! So anytime you find yourself having negative thoughts about yourself or something, imagine seeing those negative thought written across a big white board. Now see yourself taking a big eraser and erasing those words and replacing them with empowering thoughts, such as:

I succeed at everything I do. People love and respect me. Success comes to me quickly, easily, and magically. It's fun being me. I see the beauty in all things.I am a clear and open channel for the love and light of the Universe. I love being alive.

Surround yourself with positive affirmations. Write down your affirmations on Post-it Notes and place these notes all around your house, in your car, in your office drawers, and wherever else you can see and read them on a daily basis. Even though this may seem silly, try it. Pretty soon your attitude will shift, allowing you to set intentions that excite you.

Here is a mini recap

There are ways to increase the likelihood of success just by consciously setting intentions that excite you. Set your intentions before going to bed, and recommit to them again before getting out of bed.

It can be something as simple as stating;

I go through my entire day feeling well-rested, happy, and grateful for everything that is in my life. Success comes to me quickly, easily, and magically.

Form a clear picture of the desired outcome, engaging all of your senses, and focus on the kind of day you want to create. That means seeing the outcome accomplished, hearing what people will say, feeling how it will feel, and knowing that **it is done!** Eliminate any doubt that you may have. Give thanks, release the intention, be open for this or something better to occur, and don't be concerned about the details of **how it will happen.**

State your intentions in the present tense.

Your intentions are powerful thoughts set in motion.

Be specific. If you say you want to have a successful meeting without knowing what that will entail, you will never know if it happened. Be specific with all of your intentions and always allow room for that or something better to show up.

Why is it important to be clear about what you want to happen? Just imagine that you decide you want tomorrow's meeting to be a success.

What does that really mean to you? It could mean that:

- Everyone shows up, is on time, and is ready to get started.
- The attendees were impressed with the lunch you organized.
- Old connections were re-established easily and the attendees meshed perfectly, with everyone bringing unique and complementary skills to the project at hand.

Here are a few different intentions you could set for the same exact meeting. Pretend that this is the first meeting to develop the strategy for introducing and implementing a new corporate mandate. Fifteen people from five different departments and who have never worked together have been selected for this project because of their complimentary skills. Here are some intentions you could set:

- **My intention is that we get to know each other. We discuss the pros and cons** of the mandate, and come to agreement on why it makes sense and how to best accomplish the goal in the given time frame.

- **My intention is that during the meeting everyone gets acquainted**. First we split into groups and spend twenty minutes brainstorming ways to achieve the mandate. We commit to meeting once during the next week to continue considering other approaches. We will meet again next Tuesday at 10:30 to share our groups' ideas.

- **My intention is that after the meeting everyone feels positive,** energized by working with new people, and excited about meeting the challenge and as they know their solution will be well received.

So it is easy to see that setting very specific intentions increases the likelihood of success. Now that you know how to set clear, decisive intentions, you can learn more techniques for setting the stage for success.

Changing the energy in any space

Sound intriguing? Before you can change the energy in your office or conference room, you have to know how to assess the current environment. Is it negative, positive or neutral? If it already feels positive, ask yourself if you could enhance the energy even more? Conversely, if it feels negative, or not alive, you may be curious as to why. Once you pose this question, you may or may not get a flash of insight. It doesn't matter, and you don't have to believe the insight you received—it is just a good way to practice your intuitive knowing. Once you go through this exercise a few times, the process will become your own.

Please let me know if you have other techniques that work for you. Here is a great **before** of one of my offices while it was being revamped. I literally can't work or think when my space is this cluttered. So the first step is to get the mess handled before dealing with the energy in the space.

In contrast, here is my home library office just so you don't think of me as a crazy, messy hoarder.

Your goal is to create or set the energy in any space to help support you in achieving a desired outcome. You can also work with outdoor areas if you are planning workshops or seminar exercises outside. The same steps apply.

Remember to consider the look and feel of the route you plan to take when bringing potential clients through your manufacturing plant, or the route attendees will take to your meeting or conference room.

How do you set the energy? Imagine you are having an important meeting tomorrow morning in your conference room or in your home office. What do you do? I would first walk the actual route attendees would take to get to the conference room or to my office.

Why? Because I want to see what someone would observe—both visually and energetically--when first entering. My intention is to neaten up anything that looks unkempt, which automatically improves the energy.

Next I would sit in the room and close my eyes to get a sense of how the room feels energetically. Now, with my eyes open, I'd walk around the room to see how it looks and feels. If the room feels great, I'd look around again and decide why it feels good and ask myself what else I could do to enhance the energy of the room for tomorrow's meeting? For example, are all of the chairs pushed in and neatly arranged around the table? If not, I'd fix that next.

Where to start?

Be mindful and notice everything—including if the wastebaskets are empty. If there is more than one garbage can, remove the second one. If there was a water dispenser, make sure that it was filled and glasses were available. Are there any miscellaneous papers, cups, or garbage lying around to get rid of?

Is there anything written on a white board that can be erased? Are

212

there any other unnecessary or distracting elements in the room? If so, get rid of them, even if it means hiding them in a closet. If there are photos or artwork in the room make sure they are inviting and hanging straight.

Plan ahead. You want the room to support your intentions. One intention may be to create a room that is elegant, shows you care about the comfort of your attendees, and is conducive to a productive meeting.

Consider the room and the time of the meeting. For example, if the room has a window adjust the blinds or shades based on the direction the window faces, for the time of the meeting and the weather forecast—there is nothing more annoying than having the sun shine in your eyes when no one is willing to get up to adjust the blinds.

I may put a pad and pen at each place around the table. Even if people generally don't take notes on paper, the mere fact that they are there helps set the tone and implies that the items to be discussed are worth noting. If anyone makes a snide remark about the pads, you can say,

It is really there for doodling—
you know doodling is one of
the quickest ways of accessing
your creativity.

So now you think the room looks ready, right? Not so fast. While this is the first step after setting your intention, you are just setting a neutral energy field and starting with a clean slate. It is only once this is done that **the real magic can happen.**

Now you have to learn how to see what is missing. Ask yourself these questions: would a plant, a flower arrangement, or a bunch of freshly cut flowers in a vase add to the energy in the room and the atmosphere you want to create? Even an artificial plant or arrangement can have a

positive impact on the room. So why not add some foliage? You can get great-looking artificial plants and informal flower arrangements at Home Goods or Michaels for less than thirty dollars.

Foliage is always good because the color green conveys calmness, trust, nature, and beauty, all in one, making it a great subliminal addition. After the meeting is over, you can leave the plant there or keep it in your office till your next meeting.

Provide food that feeds the heart, soul, and brain. Depending on the time of day, I put out a spread of munchies. In the morning there will be freshly baked croissants. Later in the day I generally have in a bowl or two of nuts, trail mix, fresh fruit, peanut M&Ms, chocolate, protein bars, and cookies. The nuts are protein and help people concentrate—always a good thing—and the cookies and candy are there to give those who need sugar a quick sugar jolt. Providing food is another nicety that shows you care and helps differentiate your meetings.

I always bring in different types of foods, including fresh fruit, nuts, and cookies. I use colorful napkins, small china plates, crystal goblets and serving spoons.

For tea drinkers I have been serving Tea Forté teas for over twenty years. Why? Just look at

the fabulous design. Each structured tea bag has a leaf on top that pops through the lid of the teacup and makes it easy for dunking. There is also a wooden tray, and a light green, or white tea bag holder. I also always have cream, milk, white and raw sugar, honey, lemon, and *Splenda*, along with cinnamon for coffee drinkers.

Whenever I bring in fresh pastries, I make sure that attendees take the leftovers home to their family—if they last that long!

Giving out surprise presents is always a must. I always give people Red Wolf pens that are about $7.00 each that come in a cool black triangular box, a Levenger pad and a great flashlights as a thank you for coming.

I do all of these things from my heart, because I know surprise presents given for no reason are great to receive, but even better to give. If I enjoy the person, I may send home a present for their spouse and/or kids.

Here is a mini-recap that you may find helpful.

Always deal with how the space looks. Fix that first and then clear the energy.

Get a visual sense of your space—learn how to enhance the energy of your office and conference rooms to create the outcome you want by first **making the spaces more visually attractive, warm, and inviting.**

Answer these questions quickly. Feel free to write down your answers. How does your office space (or conference room) make you feel when you first walk in? What do you see?

On a scale of 1 to 10, how satisfied are you with how the space you are working on looks and how it feels? This could refer to your office, a

conference room, or any other space you plan on using. Use a scale of 1 to 10, where 1 is terrible and 10 is totally fabulous!

How satisfied are you with how your space looks? _____

How satisfied are you with how your space feels? _____

Rate your office first. Know that very few people are totally happy with how their office space looks and feels. Now that you've made up a starting point for each question, look at your office space. Do you now see things in a new light or differently?

What do you now notice?

- Are things really neat and orderly?
- Is there too much clutter or disorganization going on?
- Does it feel like something is missing?
- Does it lack personality?
- Are there any personal photos in your office, or artwork hanging?
- Do you like the color the room is painted?
- Do you have good lighting or a desk lamp?
- Do you have any of your favorite books in your office?
- What else do you see that enhances your creativity?
- Is there anything that makes you smile?
- Are there any toys or playful items in your space?

Did any of these questions spark any ideas as to how to make your workspace more energized, attractive and conducive to conversation and creativity?

Since we spend a good part
of our lives at work, it is smart to
take the time to consciously create
a space that has a positive,
nurturing look and feel,
and reflects our personalities.

You don't have to go crazy. You can start by getting rid of clutter and things you don't need or use. Next, you can bring in a few items from home that have good energy—they could include a puppet or a mouse pad with your pet's photo on it. A plant can also make a world of difference. You may not want the responsibility of owning a live plant—an inexpensive artificial plant from Home Goods will do. The goal is to surround yourself with things that make you smile.

If your office space is already visually appealing, but doesn't feel conducive to creativity, there may be other issues at play and you might want to clear the energy. To do this, open the door and windows and pretend you are sweeping out the old energy with your arms and your intentions, and now invite in the new, more fun, creative energy.

Moving on to your conference room. Here are a few examples of what you might notice that are easy fixes and will create a more harmonious atmosphere when you plan to use the space:

- Was the room left neat? If not, clean it up.
- Are the chairs around the table pushed in and evenly spaced? Think Downton Abbey, where the servants would use a ruler to measure the spacing between the place setting!
- Is there any garbage—clutter, food, dirty cups, or miscellaneous items—lying around that was left from an earlier meeting? If so, get rid of the mess.
- Are any pictures on the wall crooked? Straighten them. Did you know there is an app on your phone that gives you a level with a little bubble in the center that you can use to straighten a picture quickly without having to back up and check it out numerous times?
- Should anything be moved or added to make the space look better? It's not a bad idea to bring a plant or some flowers from home to enhance the room's visual appeal.

218

How to transform your space energetically—you can make up affirmations, say a prayer, or use a tuning fork, a Tibetan bell, or singing bowl to clear old or negative energy.

Next, take a few deep breaths, relax, and get a sense or feel for the energy in your space. How does it feel?

What words come to mind when you think of your office?

What words come to mind for your conference room?

What would it take to make your space more conducive to creativity, refresh your soul and make you smile?

Assuming that you haven't rearranged your office already, do you think something as simple as adding a plant, artwork, photos, a rug, a desk lamp or colorful pens would make a difference, not only to the visual appeal of your office but to the energy in the room? If so, how?

What can you change about your conference room?

What would it take to make your space more conducive to creativity, refresh your soul, and make you smile?

Getting a feel for the energy of a space lets you access your intuition, engage your imagination, and enhance your creativity. While initially you may not feel like you know what you are doing, there is no right or wrong approach. Make it a game. Have fun with it. Remember you get to make it up. With practice, you will get used to feeling the energy in a space, gain confidence, and become more sensitive to how energy feels in rooms and around people.

Try practicing after hours on rooms you may never use.

There are many ways to remove or clear energy from a space or room. First clear out the old energy and bring in new more vibrant energy just by opening a window and using a pad of paper to fan the old energy out. Next set an intention for how you want the room to feel. You can use sound such as a tuning fork, Tibetan singing bowl, or Tibetan bell to change the energy. Strike the tuning fork, strike or play the singing bowl or ring the bell once or twice in each corner of the room and the energy will clear.

Here is what I do before meetings. I go to the room where the meeting will be held to check it out. It doesn't matter if I have been in that room a hundred times before. I want to get a sense of how the space looks and feels right before my meeting based on who will be in attendance. That makes a difference as to how I assess the room. I will be more likely to bring in fresh flowers if I am meeting with an interior designer.

When you enter the room, expect that you will intuitively know what you can do to enhance the space based on the goals of the meeting. Pretend you are a Feng Shui Master. While it's not vital to know anything about Feng Shui, it wouldn't hurt to read or scan a book on the subject. I recommend Nancy SantoPietro's book, *Feng Shui: Harmony by Design*. There is also a book entitled: *Feng Shui for Dummies,* and plenty of free information online.

Now that you have a feel for the space, whether it is your office or a conference room, your approach will be the same. First decide how the room looks and then decide how the energy in the room feels.

Making your decisions in order—appearance first and energy second— is important. If you shift the energy first and then move things around, you will have to tune into the energy a second time because the act **of moving things does change the energy.**

To begin, simply ask yourself if the space could look or feel better? Even if you think the space looks just fine, it may look and feel very different when you are sitting in the chair in front of your desk or around a conference table. So sit in any chair, look around. What do you see from that perspective? How does the room look and feel now? Is there anything you would change?

If you are in a conference room, try sitting in several chairs as you move around the table. Each seat will give you a different vantage point, and while most of the seats you try may seem fine, you may see something you missed before.

Not sure what to think of the space? Think back to those restaurants, hotels, resorts, spas, or cruise ships that impressed you. What made them special? Was it the décor, the lighting, how the staff was dressed, the energy of the people, the attention to detail? It was probably a combination of things that made the energy in the space feel warm and inviting, letting you know immediately that a lot of care had gone into creating and maintaining every detail of the space.

Now back to your office or conference room space.

Does the energy in your space really matter? Yes, it does. That's because your intuitive right-brain automatically senses the energy in a space. Based on that instant assessment, you will either feel relaxed, anxious, or something in between.

222

Most spaces have a subtle effect on people whether they are consciously aware of it or not. For example, how do you feel when you walk into your bedroom, kitchen, basement, or garage and see everything neat and well-organized? Now how do you feel when everything is messy or dirty—imagine dirty dishes in the sink and on the counter, beds left unmade, clothes on the floor, etc.?

Did you feel your energy shift as you visualized each scenario?

"To be creative means to
be in love with life.
You can be creative only if you
love life enough that you want
to enhance its beauty, . . .
bring a little more music
to it, a little more poetry to it,
a little more dance to it."

Osho,
an Indian mystic,
guru, and spiritual teacher

Bring your creativity to life & work

It all comes down to having the right attitude
and the proper perspective in all situations, and knowing:

The importance of being happy first.
Gratitude does make a difference.
Being of service to others matters.

Want to be totally, wildly, and joyously creative? Then, as Osho says in the previous quote, you have to be in love with life and want to make your own unique contribution.

There are a few secrets that highly creative people share. I believe it all comes down to having the right attitude and perspective on all aspects of life. Why? Because:

Attitude matters

Most creative people I know are happy, playful, generous, self-reliant, passionate, optimistic, patient, honest, and determined to succeed. They are in a constant state of gratitude, and know that they are here to make a difference. Think of Sir Richard Branson.

Creative people tend to know that everything is always perfect, even if they can't see the perspective from which it is perfect. **What does that mean?** Creative people can generally maintain an inner calm no matter what happens, with a few exceptions—death, love, and taxes.

For example, when I am late for a meeting I have many ways of reacting. Such as: I **can play the victim** and blame circumstances or others for my being late—my dog hid my left shoe. **I can choose to get annoyed** and berate myself.

I can see it as perfectly fine, even though I may not know the perspective from which it is perfect. I always see everything as perfect and it always is. Since we create our reality, we might as well make up stories that are fun and empowering.

So what happens when someone is late for an appointment? Honestly, I get happy. Why? I may not be ready, and it gives me more time to **set my intentions for the meeting.** While I am waiting, I might "happen" to read an article in the *Wall Street Journal* that is germane to our meeting, or receive a report I needed before signing off on a final marketing strategy.

When I am running late, I always call the person, apologize, let her know my ETA (estimated time of arrival), and confirm that it is still okay to meet. Invariably, I hear a sigh of relief on the other end, followed by the person telling me that she or someone else was running late, as well. I know if either party got stressed out because of the delay, it would negatively impact our meeting. While I always intend to be on time, I **know being late is generally no big deal and may contain a real blessing.**

"The primary cause
of unhappiness is never the situation,
but your thoughts about it.
Be aware of the thoughts you are thinking.
Separate them from the situation,
which is always neutral,
which always is as it is."

Eckhart Tolle

First be happy

Unfortunately, most people believe that before they can be happy, something good has to happen, be achieved, or be acquired. **Most creative people tend to be happy most of the time.** They are calm, resilient, and not defeated by a temporary failure or setback. Instead they experience failure as an omen of great opportunities to come. **Believing it makes it so.**

How do you achieve a genuine sense of happiness? By living in the NOW without expectations and in a constant state of gratitude. This may seem easy when things go your way, or when events make you feel successful, but there are secrets to sustaining this same level of happiness when things are in chaos.

Remember we actually create our reality based on the stories we tell ourselves. Plato, who was born in 428 BC said,

> "Those who tell stories
> rule society."

Once we realize that only we can decide it is more fun to make up and believe stories that are empowering versus stories that are disempowering and depressing. You can create away. You have my permission. **Making up fabulous stories gives you a sense of control, which enhances happiness.**

But how does this translate into real life?

How do you react when you lose your job, someone betrays a confidence, you get an major illness, experience a death in your family, go through a divorce or breakup, or lose money in an investment?

Many people tend to get scared, fearful, furious, mad, angry, sad, upset, disappointed, depressed, or find someone to blame. They may see themselves as a victim. Or they may sink into a sense of hopelessness and give up.

They may tell themselves that they are a failure, a loser, unlucky, and even unlovable. They may decide that nothing will ever get better based on one event. You can clearly see how these negative thoughts can become a self-fulfilling prophecy and spiral out of control. When creative people fail they are generally more resilient and see the event as a good thing long-term, or as a temporary setback which makes them more determined to succeed.

When a problem occurs, it is wise to ask yourself if you are unconsciously sabotaging yourself because at your core you know that you really aren't happy at the company or with your current position. Therefore, losing your job may provide the perfect incentive to regroup and change direction.

Creative people tend to look for the good in all situations. They see opportunity in the face of failure. They believe that everything happens for a reason and that something better will show up. Where others may sink into depression, despair, or self-pity, more creative people know that **happiness is a choice, an attitude, and a way of being in the world—a choice that helps them succeed.**

Gratitude makes a difference.

Having a deep sense of gratitude for everything that occurs, without labeling it as good or bad, is important.

228

Why? Because gratitude makes you feel good, has a positive, measurable effect on your happiness, and has been shown to enhance both creativity and problem solving. Having a positive attitude also helps you generate more ideas.

Deepak Chopra says, "Gratitude opens the door to . . . the power, wisdom, the creativity of the universe."

"The greater your capacity for sincere appreciation, the deeper the connection to your heart, where intuition and unlimited inspiration and possibilities reside." HeartMath Institute.

Coming from an attitude of gratitude when facing setbacks and crises lets you harness your creativity, helps you generate new ideas, and see opportunities that would not exist if the problem didn't exist.

Did you know that helping others actually feels good and affects your mood more positively than previously recognized? It's true. So if unleashing your creative potential is high on your priority list, consider volunteering at a hospital, a women's center, a soup kitchen, or an animal shelter. Once you see how appreciative others are in spite of their condition, you will abandon any pity party you had planned, and your gratitude will multiply.

It is only when you serve others that you truly feel good about yourself and love yourself. Want to know why? When you come from a place of service, you finally stop being self-absorbed, and begin to focus your attention and loving kindness on others.

Don't know where or how to start? Take baby steps. For example, when food shopping, talk to the cashier. Really connect. Address the person by name, pay them a compliment, smile, and ask them a question that requires more than a yes or no answer. Let them know you see them as a person that is not defined by their job. See how connecting with a stranger makes you feel. Chances are you will find yourself smiling and feeling good, as well. This is real happiness because it comes from your heart and makes a difference. It also feels wonderful because there is nothing you want in return.

Why is it so hard to be happy most of the time?

Unfortunately, as a society we have been conditioned to believe that we will **ONLY** be happy **WHEN** something happens, or **WHEN** we acquire just one more thing, such as: _____ (*fill in the blank*).

The most obvious examples are: **You will be happy when you:**
 * Get into a prestigious school
 * Graduate
 * Lose weight
 * Fall in love
 * Get engaged
 * Plan the perfect wedding
 * Get married
 * Get the perfect job
 * Make a million dollars
 * Buy your first home
 * Buy a bigger home
 * Have a child
 * Can afford that Mercedes or BMW

And the list goes on . . .

While these are all fine goals, they all have one thing in common— they are based on the notion that **"happiness" is predicated on achieving something in the FUTURE.** This pattern of thinking keeps us on a treadmill, always chasing what is next and never stopping to appreciate what we have or have just achieved. Since the future is unattainable, happiness can never be experienced.

Chasing after this elusive sense of what we think will make us happy robs us of being present, which is so sad. It is only when we are present in the moment that we can experience real happiness--the kind of happiness that comes when we stop and are grateful for all those things we generally take for granted: our lives, health, friends, family, the environment, and the abundance of resources and opportunities we have.

Want to see how easy it is to feel gratitude? Try this. Take a deep, slow breath, breathing in through your nose with your mouth closed. Make sure you are taking a really deep breath—the kind that causes your belly to expand. Hold your breath for a few seconds. Now exhale, bringing your belly in toward your spine to force more of the air out.

Now do it again, only this time inhale for a count of four, hold the breath for a count of four, exhale for a count of six, and hold for four counts. Feel how precious that one breath is. It will make you appreciate each breath even more. This conscious breathing is a form of meditation.

Repeat this same slow breathing, only this time place your tongue on the roof of your mouth right behind your teeth, and as you slowly inhale, let your shoulders drop and relax. Exhale. Take one more breath in, using the same technique—inhale for four, hold for four, exhale for six, and hold for four—only this time feel the stillness as you suspend breathing between the inhale and the exhale.

Being happy in the present moment can be simple no matter what is going on in your life—including all of the things we tend to **label as** "bad," such as being sick, getting fired, ending a marriage. What is the key to being happy in the worst of times? Here is the mantra I made up years ago that works for me:

I know that everything
is always perfect,
even when I don't see
the perspective
from which it is perfect.

Also take comfort in the saying . . .

"Out of great
chaos
comes
a higher order."

Friedrich Nietzche

Trust that all is really OK. Tell the Universe that you are ready for miracles and magic to appear. You can even ask for unicorns and angels to be with you—they make great playmates

Years ago I was taught that **there are only three things that can make you miserable:**

labeling yourself and others
judging yourself and others
comparing yourself to others

So now, when an event happens that initially seems dreadful, terrible, or scary, stop and tell yourself that it may really be a blessing on some level. Instead of reacting from a space of fear, **practice taking a neutral response to all events. Stay calm, smile, and look for the cosmic humor or message in all that occurs.**

Take several slow, deep, calming breaths—in through your nose, pause and exhale, pause and repeat. When your breathing is calm, your emotions will match the attitude your breath creates.

If you are outside, really look at something in nature—the bark of a tree, a blade of grass, a leaf that is on the ground, tiny plants growing in a field, or a rock.

Touch it, smell it, examine the complexity of the object up close from all angles. Know that it is alive and perfect just as it is in that exact moment. So, too, is every moment in your life perfect—all you have to do is stop and realize that everything is perfect and that out of adversity comes great new surprises from the Universe.

Still not convinced that you can be happy in the moment without attaching happiness to achieving something in the future?

Then read Shawn Achor's book: *The Happiness Advantage: The Seven Principles that Fuel Success and Performance at Work.* The blurb on the back cover summarizes the overriding insight he shares in just three sentences:

"Everyone knows that if you work hard,
you will be more successful in life,
and if you are more successful,
then you will be happy, right?
Recent discoveries in the field of
positive psychology show that
the above formula is actually
backward. The truth:
Happiness fuels success,
and not the other
way around."

So, if we have to be happy first to be successful, how do we do that?

Decide to be happy—*just smile and you will feel better*

Practice gratitude—*think of just one person or animal you love and know that they love you*

Come from a sense of service—decide to do one nice thing for someone else—such as holding a door open, smiling at a stranger, sending love an invisible hug to a stranger, forgiving someone you are angry with and forgiving yourself for holding on to negative energy

Gratitude does make a difference

If you don't know what being grateful looks like, try this:

1. **Look at your thumb.**

 Move it back and forth. Notice how quickly and effortlessly it responds to your non-verbal direction. Think of all of the billions of "behind the scenes" activities that have to take place in your brain and body for your thumb to move.

 Imagine people who have no thumb or movement in their thumb. Now look again at your thumb. Realize that without the use of your thumb, there would be countless things you couldn't do. Appreciate your thumb—the same thumb that we take for granted 24/7. Stay with that thought for a minute or less. Tell your thumb how beautiful and precious it is. How do you feel? Now send loving energy to your entire body as you thank every cell for keeping you happy, healthy, and alive. Are you smiling? Good! Recall that feeling any time you want to be more creative.

2. **Go outside and look at a leaf**—any leaf. It could be a bright, shiny, green leaf, or one that has turned brown and is lying on the ground. Take a minute to appreciate how beautiful that leaf is. Look at the tiny veins, the size and shape, the texture and color of the leaf on both sides, and inhale its scent. Thank it for being a part of your world. Doesn't that sense of gratitude make you stop and appreciate life more fully? Notice there is even beauty in old "dead" leaves with pieces missing—but that is for another book.

3. **Look at a plastic straw.** What do you see? Describe it to yourself. If you are like most of us, you might think, "it's a colorful plastic straw. But what's the point?"

 Now before I share my way of looking at any and everything— from a "dead" leaf to a straw—ask yourself if you have ever thought about what it takes to produce this one straw that you mindlessly use and quickly discard? Most people would think *plastic,* and they'd be right. **Then ask yourself where does plastic comes from.**

 With a quick Google search, which could have lasted for hours because it was that interesting, I learned that plastic is made from many things such as: coal, natural gas, minerals, plants, and crude oil, etc. The ingredients vary based on the type of plastic and the desired properties.

 Now think of just one of the elements used to produce plastic and ask yourself: what does it takes to produce the minerals, natural gas, or plants used in the various types of plastics? Going beyond the ingredients, think about the people who invented plastic, and designed and manufactured the machinery to make it all possible.

Now imagine all of the many scientists, chemists, researchers, and lab techs involved in creating the plastic for the straw. Think of the researchers in chemistry labs. Can you picture the test tubes and glass beakers surrounding them?

Ask yourself who made those test tubes and beakers, and where the properties used to create the glass come from. Look around the same lab and ask yourself who made the bright red EXIT signs and where those materials come from. Traveling down this rabbit hole can last for days. The point being, there are so many elements and so many people to be grateful for, along with Mother Nature, for all of the raw materials used in the products, that we could never thank everyone.

4. **When I discard a piece of paper,** I think of all of the people around the globe who don't have enough to eat, let alone a sheet of paper to draw on. I feel doubly blessed to be living where I am and at this time in history. Can you image the pioneers who traveled across the United States without air conditioning, maps, or Whole Foods? I shudder at the thought!

5. **Keeping a gratitude journal** can be a very powerful practice, but it requires that you stop for a few minutes a day and really appreciate just how fortunate you are—especially when you are facing difficult challenges on multiple fronts. During the good periods of your life, remember the rough patches and be grateful for how far you have come.

Reseach has proven that the physical act of writing in a journal is much more powerful than just thinking thoughts of gratitude. Entries can be as short as a sentence or two. Why? According to Robert Emmons, one of the world's leading experts on the science of gratitude and author of the seminal studies of gratitude journals, translating our thoughts into the written word helps to make us more aware of what we are grateful for and the act of writing has a greater emotional impact than just thinking it.

Take this practice seriously. For journaling to be effective, you have to list more than just the obvious—your health, family, friends, and children—**and start really noticing all the things you take for granted. That is when the real magic happens.**

So instead of mechanically listing the obvious, become conscious of all of the things that contribute to the quality of your life that you don't normally consider. Think about the stars, the rain, the beauty of a spider

web, the washing machine and how much time that saves you, the electric light that makes reading at night possible, the pattern of the whiskers on a cat, the design of a box that candy comes in—the list is endless. When you begin to notice everything you don't appreciate, you wake up and smile.

For example, when was the last time you appreciated a handful of sand on the beach? Isn't it amazingly beautiful? Notice how it sparkles in the sunlight.

If you decide you are grateful for an object such as your baby grand piano, don't just think, **"I am grateful for my piano." Rather notice the beauty of the piano from all angles, the smoothness of the keys that were handcrafted from ivory, the elegance of how the wires are aligned inside the piano. Then listen to the sound.** Mentally say, "I thank you, piano, for being in my life. I will always honor and take care of you."

Next thank all the people, living and dead, who were involved in producing your piano—especially Bartolomeo Cristofori, the man who created the very first type of piano in 1700 in Florence, Italy.

It can be challenging to remember to be grateful once your workday begins. It is easy to get consumed by stress when you focus on the negative aspects of your job, the pressure, or some of the people you work with. That pattern of thinking is still another rabbit hole that can fill your head with negative thoughts as you spiral out of control. When you find yourself going down that never-ending rabbit hole, decide that it's time to regroup and remember all of the things you take for granted—like a stapler that isn't empty when you have a few more reports to staple and you are already running late for a meeting.

Remember that being happy, being grateful for everything, and helping others generates the energy needed to awaken your creativity.

When you serve others you find happiness

Coming from a sense of service accomplishes many things. It engages your creativity regarding how you can be of service, whatever that means for you. It puts life in perspective, helps you be in the moment, and stops you from being so self-absorbed.

In fact, many research studies have proven that being of service and giving of yourself makes you happy. Just try it. Start out simply. Hold the door open for someone behind you, especially when it means lingering a few seconds longer. Smile. I especially enjoy holding the door for college kids and really old people.

Here are a few of my favorite things to do:

- **When I am in the store** or on the street, I imagine sending lots of love and light to everyone in the store or within a one-mile radius.

- **I buy stuffed animal toys for dogs**, cats, and children whom I haven't met yet. I keep them in the trunk of my car for the sole purpose of giving them away when the mood strikes. I also keep a box of dog treats to give away. It is not only fun to give animals toys, I love seeing how the owners react.

- **I stay alert for opportunities to be of service to others.** When I see a mother pushing a stroller with one too many children in tow, or an older person who is having difficulty walking or has one too many bags to carry, I offer to help.

- **If someone in line behind me has just a few items to purchase** and I have many more things, I insist that they go ahead.

Look beyond those situations where your help would obviously be appreciated, and see if you can make another person smile—just because you took a few seconds to hold open a door, smiled at them first, and responded to their thanks with, "My pleasure," or, "I love your coat." You get the idea.

Gratitude gives us an entirely new perspective. It intensifies our appreciation for being alive and for all the gifts we take for granted.

Here are two last things to think about in your quest to be more creative.

Love and appreciate yourself.

Take a deep breath, and repeat this phrase throughout the day:

I am enough. I am loved. I truly love myself.
Thank you, God, for all of my blessings.
I am love and light. I make a difference
in the lives of many people, many of
whom I will never meet.

Let others be of service to you. Receive their help graciously and let them know how much you appreciate their kindness or generosity.

Starting seeing things differently. If your goal is to be more creative, remember it doesn't mean having one great idea; it means having hundreds of ideas. How do you get into a creative mindset? Decide you are creative and start seeing multiple possibilities in everything you see and do.

Creativity doesn't just happen in one domain of your life. It becomes a way of life, and is what makes being alive fun. It is seeing multiple possibilities for creating new things out of a piece of packaging, literally moments before you are ready to discard it. Start training yourself to see the beauty in everything.

Start playing and making things just for FUN.

It is fun to see a range of possibilities for recycling what would be labeled as garbage. For example, I became slightly obsessed with a brand of triple-cream goat milk Brie that came in round wooden boxes about 5" in diameter.

These boxes were just too beautiful to discard—especially since I could see so many possibilities for repurposing them. So I started saving them, and only stopped when I had amassed fifteen-plus boxes, which were now taking up too much space.

When I see many uses for what others consider garbage, I am never compelled to actually create the items. Rather, I enjoy visualizing the end results, and put the item back for another day. So just because you have a great idea, it doesn't mean you have to execute it. Imagine some uses for the Brie boxes.

Jot down all of the things that come to mind now.

Here is my list:

I could make a mobile. In a flash, I imagined spraying the four boxes inside and out, lid and bottom, with a matte black spray paint. Next I would find sixteen of my favorite photos—ones that make me happy: photos of my granddaughter, Isabelle, my husband, our cats, leaves, and some mountains in Santa Fe. I would enlarge and print all of these so there

would be enough image area to cover one side of the box. I would glue or decoupage the photos on the boxes and add whatever other little three dimensional items that would add a sense of whimsy. I would make small holes on top of each box and create a hanging mobile using a piece of a tree branch as the horizontal support and colored threads to suspend each box from the branch.

Make a happy box of smell-good things. Spray both sides of the lid and bottom of the boxes in happy colors. Put fragrant items in each, such as dried lavender, rose petals, rosemary, small pieces of wood chips sprayed with pine scent, or sand and seashells sprayed with perfume. Then drill small holes in the lid of the box so the smell can be enjoyed. Put the boxes in drawers or around the house. The lids can also be decorated based on the person you want to give it to.

Transform them into surprise gift boxes. Who doesn't love a surprise present? First I imagined creatively decorating the boxes. Instantly they were transformed into little gift boxes. I envisioned using decoupage to glue photos on the surface and adding different colors of glitter and beads.

Then I pretended that whenever I was out and about and found something small enough to fit in the box, I would buy it with no specific person in mind. This way I could give these little gifts away when my intuition reminded me that they existed.

I decided that I would let my spirit guides select who would get what present and when. Then an idea for making the gift-giving even more fun occurred to me. I imagined showing a friend four of these gift boxes and letting her pick the one she want without knowing what was inside.

If she didn't look pleased with her selection, that would be perfectly fine—and the perfect excuse for playing another game. I would

tell my friend that I would pick another box for her and she could see which gift she liked better. After seeing the contents of the second box, I would make her pick once again so she would take the gift she liked the best. Finally I would have her open the last box and then choose her gift.

This game would be especially fun because I wouldn't remember what was in the four boxes, so I would be as equally surprised and excited as my friend to see what was in them.

I began playing a version of this game with my granddaughter, Isabelle, when she was three. Here is how it worked. I would hide multiple presents for her in my bedroom. One present might be behind a door, another under a pillow on my bed, one in a drawer left slightly open, and yet one more left in plain sight on a counter. This way, Isabelle got an added gift of getting to go on a treasure hunt to find her presents. In the beginning, I taught her how to find the presents by playing, "You're getting warmer", or "You're getting colder," when she was moving in the wrong direction. This was great fun.

Of course she knows me too well, and knows that I would NEVER have just one surprise for her. During one vacation I spent in Mexico with her (real grown-ups were there too,—her parents and my husband) I hid over fourteen presents for her over the course of several days. On the very last day I sadly confessed that I didn't have any more presents for her to find. She just looked at me and said, "That's okay, Grandma, you can just hide the toys you already gave me." I think she was five at the time.

As she got older, hiding gifts became more challenging. When she was eight, I had to step up my game. Since Isabelle is artistic and fun to paint with, I bought her some art supplies at Michaels. I got carried away and bought way too many. Now, there was no way I could hide all of these things —because I wouldn't remember where they were hidden.

So obviously I had to invent a new game. The idea, like all brilliant ideas that come to me, came directly from the Universe. I named the game **THE BOX OF BLINDNESS**. Sound strange?

I threw the presents in the trunk of my car all jumbled around. Next I took Isabella to the back of my car and put an empty Pellegrino box over her head so she couldn't see what was in the trunk. Then I told her to root around and pick an item that felt like fun. To my total delight and amazement, after selecting an item and with the box still over her head, she asked, "Grandma, in your opinion, would this be a good present to keep?"

Isabelle Tulip Wildenboer

Obviously, during each trip to the trunk she got to pick multiple things and more . . . as planned. Why, you may ask?

See this face? This is her asking for just one more thing. Which as you can imagine was never just one more thing. I loved every minute of this game. Feel free to try it. It also works with adults, and you don't have to drink a case of sparkling Pellegrino water first—you can use any type of box.

Isabelle Tulip Wildenboer

Where do these ideas come from? God, the Universe, your higher self, your cat—it doesn't matter what you tell yourself. For me, I always give the Universe credit, unless I lost something in the translation—but that is yet for another book.

The point is, as you learn to slow down and appreciate the shapes, designs, colors, patterns, smells, textures, and minute details of things you never really explored before, you begin to see things differently. This is an important aspect of creativity—**to see the beauty in all things regardless of outward appearances.**

But most people won't risk sharing ideas that could seem "too whimsical, or bizarre," unless they truly honor who they are and appreciate that their contribution might make a difference or spark an idea in someone else who might be too self-conscious to speak. So if within your belief system you hold the notion that you aren't creative, smart, clever, loved, appreciated, or whatever else might be holding you back, it is time to eliminate that underlying belief.

How do you do it? Ask your ego brain to step aside. Trust those ideas that come through, which really have very little to do with you and which should be shared without fear or editing.

Long story short: In order to be creative, you have to be willing to share, honor who you are, and value the contribution you make by just by being alive.

"One individual who lives and
vibrates to the energy of pure love
and reverence for all of life
will counterbalance the negativity
of 750,000 individuals who
calibrate at the lower,
weakening levels."

Dr. Wayne Dyer

RESOURCES / BIBLIOGRAPHY

Edwards, Betty, *Drawing on the Right Side of the Brain*. New York: St. Martin's Press, 1989.

Brown, Stuart, MD, *Play: How it Shapes the Brain, Opens the Imagination, and Invigorates the Soul*. New York: Penguin Group (USA) Inc., 2009.

Nelms, Henning, *Thinking with a Pencil*. Girard & Stewart, 2015.

Hanks, Kurt and Belliston, Larry, *Rapid Viz*. Cengage Learning PTR, 2006.

Carroll, Cain and Carroll, Revital, *Mudras of Yoga: 72 Hand Gestures for Healings and Spiritual Growth*. Singing Dragon, 2014.

Images

Pg 3	TSCHITCHERIN / Shutterstock
Pg 27	Vadim Georgiev / Shutterstock
Pg 28	Wave Break Media / Shutterstock
Pg 32	Monika Wisnewska / Shutterstock
Pg 33	Cain Carroll / Mudras of Yoga
Pg 35	KI Petro / Shutterstock
Pg 36	OPOLJA / Shutterstock
Pg 39	Christian Chan / Shutterstock
Pg 44	Leigh Prather / Shutterstock
Pg 47	Myron Pronyshyn / Shutterstock
Pg 55	Gustavo Frazao / Shutterstock
Pg 61	Lina Lisichka / Shutterstock
Pg 61	WHO IS DANNY / Shutterstock
Pg 67	Antonio Diaz / Shutterstock

RESOURCES / BIBLIOGRAPHY

Images *cont.*

Pg 104	Sophia World / Shutterstock
Pg 107	mimagephotography / Shutterstock
Pg 108	EFKS / Shutterstock
Pg 114	Alan Uster / Shutterstock
Pg 119	BW Folsom / Shutterstock
Pg 120	Leszek Glasner / Shutterstock
Pg 121	Be Light / Shutterstock
Pg 130	Diego Schtutman / Shutterstock
Pg 136	Dorottya Mathe / Shutterstock
Pg 142	CHOATPhotographer / Shutterstock
Pg 148-149	Lucky Busniess / Shutterstock
Pg 155	Peter Hermes Furian / Shutterstock
Pg 163	DIKAR / Shutterstock
Pg 167	Cain Carroll /Mudras of Yoga
Pgs 168-174	Cain Carroll /Mudras of Yoga
Pg 197	Rohappy / Shutterstock
Pg 200	Sirtravelalot / Shutterstock
Pg 201	BW Folsom / Shutterstock
Pg 204	Markus Gann / Shutterstock
Pg 207	Alan Suster / Shutterstock
Pg 209	Sergey Nivens / Shutterstock
Pg 226	Alina Cardiae Photography/ Shutterstock
Pg 228	MAEWJPHO / Shutterstock
Pg 229	Peshkova / Shutterstock
Pg 231	wow.subtropica / Shutterstock
Pg 233	macknimal / Shutterstock
Pg 235	TITIMA ONGKANTONG / Shutterstock
Pg 237	Vorobyeva / Shutterstock
Pg 238	Africa Studio / Shutterstock

All other photos not listed were taken by Lynne Evan Hoinash.

Neal Donald Walsh once said,
"Life is not about you."

I believe those words. The sooner
we realize that true happiness
only comes from connecting with
Source and being a clear and open
channel for the love and
light of Universe.

Lynne Evan Hoinash

Lynne Evan Hoinash MBA, MAM, has over thirty-three years of business, marketing, and branding experience. In 1987, she founded Red Wolf Design Group, an all-woman advertising, branding, and consulting firm in Princeton, NJ. She created an innovative approach to marketing based on trusting her intuition or "inner knowing" to tap into the specific needs of each client. From this perspective, she and her team developed marketing strategies, programs, and materials that helped her clients establish an emotional connection with the end user. Her clients included Fortune 500 companies and mid-sized B2B firms, along with start-ups across a wide range of industries.

Lynne earned her MBA and MAM from Simmons School of Management in 1977. She is a student of spirituality, a variety of healing modalities, neuroscience, the evolution of consciousness, and creativity. In her free time, she entertains, paints, takes photographs, skims about five books a week, comes up with numerous ideas to help implement change, and plays with her cats.

Lynne has authored a series of books which will be available shortly, including *Awaken the Creative Genius Within* **Workbook**, *Awaken the Creative Genius Within* **Using a Pendulum**, *Awaken the Creative Child Within*, a book for people of all ages, and several children's books: *Two Stories of Love & Miracles*, and *My Fingers Are Magic and Make Me Smile!*

Lynne lives in Princeton NJ, travels extensively, and has deer in her backyard. She is an artist, and an aspiring enlightened being… or not.